Thomas Maschke/Peter K. Burian
Minolta Maxxum 700si and 400si

Thomas Maschke/Peter K. Burian

MINOLTA
MAXXUM™
700si
and
400si

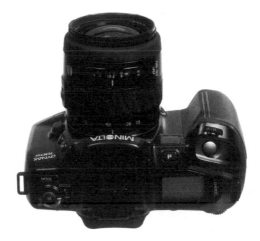

Laterna magica

Magic Lantern Guide to
Minolta 700si and 400si

A Laterna magica® book

First English Language Edition March 1994
Published in the United States of America by
Silver Pixel Press
Division of
The Saunders Group
21 Jet View Drive
Rochester, NY 14624

Based on the German editions Minolta Dynax 700si
and Minolta Dynax 400si by Thomas Maschke
Edited by Peter K. Burian
Translated by Hayley Ohlig
Production Coordinator: Marti Saltzman
Editorial Assistant: Mimi Netzel

Printed in Germany by Kösel GmbH, Kempten

ISBN 1-883403-08-1

Contents

Introduction to the si Series

Contrary to popular opinion, Minolta did not pioneer the autofocus (AF) camera. In fact, a number of prototypes were shown by other manufacturers as early as the mid 1960's at the Photokina trade show in Cologne, Germany. Much of the technology in use today is based on a prototype developed by Leica (for the Leitz Correfot) and subsequently refined by Honeywell. But in spite of all the advance research, development, and tinkering by engineers from Europe to North America and Japan, Minolta was the first to produce a commercially viable autofocus SLR, the Maxxum 7000 (Dynax 7000), which was released in 1985.

That "first generation AF" camera proved to be a stellar success, both in sales and in acceptance of the self-focusing concept by many (but certainly not all!) photographers. Having owned one of the very first to reach North America, I can attest to its high level of appeal and also to its limitations. Most notable was the lack of Continuous AF. Even a slow moving subject, such as a toddler approaching, was not sharply rendered. This was because the system was unable to track motion. Focus was set for a certain point, and if the subject moved beyond it, an unsharp picture would result unless depth of field was adequate to mask the focusing error.

Maxxum/Dynax Designation

Throughout this guide we refer to Minolta's autofocus SLR cameras as Maxxum/Dynax because of the two designations used by the manufacturer. In North America, the name Maxxum has been employed since 1985 but elsewhere the same cameras have borne the Dynax logo. Contrary to the approach taken by some other manufacturers, the actual model numbers (such as 700si) and the features, usually do not differ, no matter where they are distributed. However, the new Maxxum 400si is an exception to this rule, as it is called the Dynax 500si elsewhere.

Developments in AF Technology

By the time of Minolta's "second generation" autofocus system, available in the i-Series Maxxum/Dynax cameras, technology had advanced substantially. Subjects moving toward the photographer at a modest and constant rate of speed could be followed by the system; hence the term "follow focus".

But motion in other directions, especially if erratic or varying in speed, still created an insurmountable challenge for the AF system. Thankfully, by the early 1990's, this problem had been solved as well. Some of the "third generation" Minolta AF cameras, the xi-Series, incorporated Omni-Dimensional Predictive Focus Control, arguably the most advanced for its time.

This system would automatically detect motion and adjust focus continuously to keep up with variations such as when the subject accelerated, slowed to a stop, restarted, or made a U-turn. Thanks to the addition of advanced artificial logic, designated as "expert intelligence", and a wide (four segment) focus area, substantial improvements in autofocus became possible. The system could determine your subject's actual position in the frame at the instant of exposure, keep up with those moving a full three times faster, maintain focus on off-center subjects, and recognize additional "dimensions" of motion as mentioned above. Pressing the shutter release enabled the xi-System to accurately anticipate the position of a moving subject at the instant of exposure.

In my tests with Indy cars, triathalon cyclists, and the high speed action of powerboats traveling at speeds of 100 mph (168km/h), most every frame was rendered perfectly sharp. Because the Omni-Dimensional Predictive AF system analyzed subject motion, magnification, distance, and position in the frame continuously, the 7xi and 9xi were able to respond in milliseconds with accurate focus and exposure. "Autofocus has finally been perfected", some of the photo magazines declared, without much argument from us.

The Fourth Generation AF

Improving on perfection is no small feat, but Minolta has achieved just that with the Maxxum/Dynax 700si by incorporating the fourth

generation of an increasingly successful AF technology. While the improvements in performance are not all dramatic (because the xi-Series was already so successful), we'll stop short of calling the 700si a "milestone" in development. But, as detailed in a subsequent Chapter, the AF system is indeed more reliable, particularly in the ability to track high speed action relentlessly. (As with any AF camera, the most impressive follow-focus performance is achieved with "fast" lenses [such as f/2.8] in bright light, but the 700si outclasses its predecessors in difficult conditions too).

Even more important in our estimation are the other improvements and enhancements: in additional features, superior handling and control qualities, and responsiveness to the photographer's needs. There's much less fiddling with small buttons, fewer occasions where the camera takes over control, fewer distractions in the viewfinder; and a greater overall responsiveness to the demands of the advanced photographer.

New 700si Capabilities

Although we will examine the camera and all its features in detail throughout this guide, let's preview the primary advantages of the 700si over the previous Maxxum/Dynax xi-Series models. According to Minolta's Press Release, the designation "**si**" denotes "sophisticated intelligence which comprises high performance automation, interactive creative control, and comfortable handling". While this may sound like advertising hype, we found it to be quite true in extensive real-world photography.

By "interactive" we mean that the camera is highly controllable with a logical operating sequence, accessible controls for quick changes to settings, and in constant communication with the user. Pick up the 700si and it feels immediately comfortable. Important controls fall at your fingertips. Look in the viewfinder or check the LCD panel and you find full feedback as to where the camera is focusing and how it is metering, for example. Accept its selections or use the information to guide your course for corrective action.

The following additions and enhancements over the already impressive 7xi/9xi keep the Maxxum/Dynax 700si competitive with the best other manufacturers have to offer:

- Improved AF system for faster subject detection; superior response with low light/low contrast subjects; substantially increased AF speed and tracking ability
- Design improvements with simplified, larger (and more accessible) controls for greater ease of use
- Hushed film advance and rewind; high speed rewind option
- Built-in flash, covering the angle of view of a 24mm (instead of 28mm) lens; manually raised instead of popping up when not desired
- An optional Vertical Control Grip, with second set of controls for improved handling in a vertical orientation
- Choice of three battery types with the VC-700 Grip plus threaded sync cord terminal for connecting non-dedicated flash units (9xi includes terminal in body)
- "Memory" function for storage and instant recall of a favorite combination of camera settings
- ON/OFF switch for Eye-Start Automation
- Spot Meter button for instant access to narrow area metering without removing the camera from eye level
- Convenient rear-mounted AF button which defines which of the four sensors has achieved focus (also used to select any of the four sensors on demand)
- Autoexposure bracketing
- Depth of field preview/stop down control (previously available only with 9xi)
- Flash exposure compensation button to control ambient to flash lighting ratio with integral or attached (or wired remote) flash unit
- With the 5400HS Maxxum/Dynax flash unit, High Speed Flash Sync at up to 1/8000 sec.
- Elimination of extraneous viewfinder displays (which were superimposed over the viewing screen of the 7xi)
- Improved honeycomb pattern evaluative metering for greater accuracy in difficult lighting conditions; autofocus information on subject location improves accuracy
- Smaller and lighter camera body
- Panorama frame preview without installing panorama screen; available on demand at any time
- Frame counter in viewfinder data panel for last nine exposures on a roll

- Metering Index Scale as in the 9xi (superimposed over the viewfinder) with increased feedback on exposure in any Mode, metering pattern and auto bracketing

Evaluation of 700si Features

The bottom line, based on my field tests of the Maxxum/Dynax 700si, is this: The camera offers superior handling, a logical sequence of controls, plus instant and reliable response in virtually every challenging situation we could find. Every feature and setting can be overridden, usually without removing the 700si from eye-level. This is a camera that someone making the transition from a mechanical SLR can begin to use quickly. Some of the advanced functions do require study and subsequent reminders as to operating sequence from the Quick Reference Guide at the back of the Owner's Manual.

In our estimation, the 700si will surely satisfy the photo enthusiast who values speed, convenience of use and streamlined operation (as compared to some other AF cameras). Its commendable performance is perfect for capturing the decisive moment in candid pictures of people, during travel, sports or other action, and in flash photography. With its sophisticated artificial intelligence, this SLR can immediately raise the level of technical achievement, encouraging the progress of aspiring photographers.

If we have characterized the 700si as an action photographer's camera, we have unfairly restricted its scope, however. In truth, this is a capable companion in creative and interpretive work too, although few of the controls will lock. Auto-exposure bracketing, for instance, requires constant pressure on two buttons, less than convenient when using a tripod. In such thoughtful pursuits, we often used the fully manual approach, with extensive metering guidance enabling us to achieve any intended effect.

Unlike the entry-level models, the 700si will continue to "grow" with its owner. Add a few of the Creative Expansion Cards and the 5400HS flash, and the system becomes even more versatile, helping to explore advanced techniques for years to come.

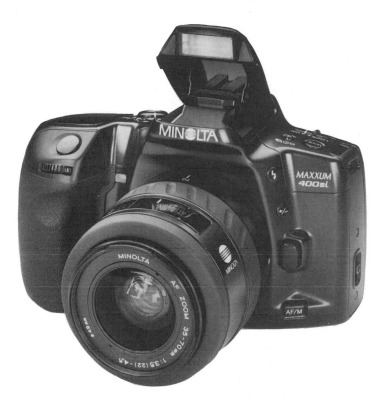

The Maxxum 400si is a well-designed, affordable camera with every feature necessary for complete photographic control.

Introducing the 400si

Since not everyone needs or wants a camera with a full complement of computerized capabilities, Minolta introduced the Maxxum/Dynax 400si at a substantially lower price. Because there are fewer features and buttons, it appears less intimidating, but can still meet some of the demands of experienced photographers. This is primarily a Program camera but with other creative modes plus full metered manual control.

We will devote an entire Chapter to this mid-range model. Owners of the 400si should review certain sections relating to the 700si as well – on exposure metering, on some of the technology, the use of Programmed modes and overrides, the various AF

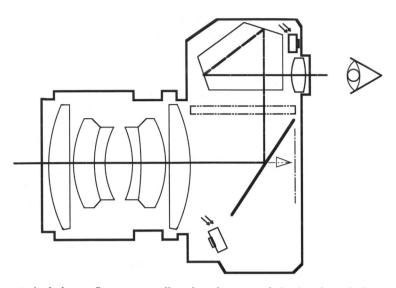

A single lens reflex camera offers the advantage of viewing through the picture-taking lens. As light passes through the lens it is reflected by a front surface mirror through the prism of the camera to the viewfinder. When the shutter is released the mirror swings up out of the way so that the light travels directly to the film. The design of the SLR essentially means that the photographer has the benefit of viewing the image exactly as it will be recorded on film.

lenses, film and lab selection criteria, the hints for better photos, and so on. But remember: many of the controls and features of the 700si were not incorporated into the 400si to avoid overcomplicating and overpricing the camera. Hence, review the pertinent Chapter, your Owner's Manual and the Specifications Chart to prevent confusion. You'll soon recognize which functions differ or are not available with the 400si.

The sections of this guide which will not apply to 400si owners include the following: Spot metering, multi point Omni-Dimensional AF, Metering Index scale, depth of field preview, Memory function, Metering Index, Expansion Cards, High Speed

Flash Sync, flash exposure compensation, AE Bracketing, double exposure and film advance options, Center Weighted metering, the AF options, the VC-700 grip, Eye-Start, panorama frame preview, and manual film speed override.

While the above may lead to disappointment, keep this in mind: no one needs every capability ever invented to create dynamic images. Many professional photographers still use SLRs with fewer features than in the 400si (though with depth of field preview). So concentrate on maximizing the value of the available options and on the essential facets of photography: effective composition, choice of subject matter and perspective, the creative use of light and technical or aesthetic excellence. Just about every technique for creating better pictures and greater visual impact applies equally to both the 700si and the 400si.

Note: *Throughout this Guide we use the terms "**Aperture Preferred**" and "**Shutter Preferred**" to define the two semi-Automatic modes. Minolta Instruction Manuals refer to these as "**Aperture Priority**" ("**A Mode**") and "**Shutter Priority**" ("**S Mode**") **AE** (denoting Auto Exposure). Consider the two sets of terms interchangeable, with an identical meaning.*

The Maxxum 700si - Feature Guide

Let's begin our test drive of the 700si by briefly reviewing the most important features. Each will be explored in depth in subsequent chapters.

According to Minolta, the design of the Maxxum/Dynax 700si was based on extensive feedback from both amateur and professional photographers. Any deficiencies from previous models were addressed. For instance, the built-in flash now illuminates an angle of view covered by a 24mm lens (instead of 28mm). In addition, the best of the capabilities of the "pro" 9xi were incorporated into the 700si, a camera that will set the standard for a long time to come.

The research on which the 700si was based determined that an "ideal" SLR would be required to satisfy 3 needs:

• advanced automatic modes
• all options required for creative control
• ease of use

The Maxxum/Dynax 700si is a more successful combination of these requirements than its predecessors. This makes it a superior tool for the serious photographer who wants to transform his concepts into an image on film.

Superior Autofocus Capabilities

For instant response to moving subjects, the ultra-wide focus area allows the photographer to capture even erratically moving subjects. Four highly sensitive CCD sensors are arranged in a pattern which improves subject detection accuracy. Improved data processing enables the AF system to lock onto subjects more than

◁ **The Maxxum/Dynax 700si is fully responsive to the photographer's demands: from fully automatic Program selection to manual exposure metering, this camera incorporates virtually every capability. Essential overrides ensure that the photographer can regain complete control over image creation.**

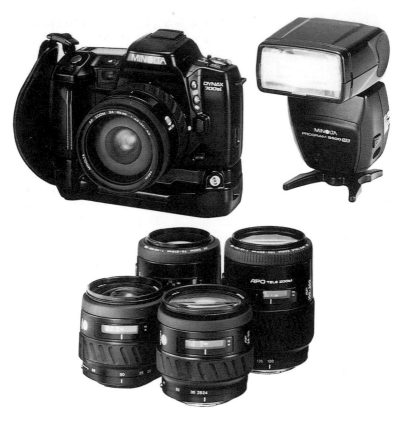

Before deciding on the final design, features and controls of the 700si, Minolta sought advice from experienced photographers. Unlike some cameras which were created solely by engineers, this model should certainly please the advanced user.

twice as quickly as the earlier 7xi/9xi. Superior low contrast capability allows positive focus on distant subjects such as mountains and clouds. The 700si is also more successful in accurate focus under low-light conditions, down to EV -1, and is surpassed by no other current SLR.

The wide AF sensor area helps to maintain focus on a moving subject, an important consideration in action photography. And the 700si will shine in such pursuits thanks to its Omni-Direc-

tional predictive autofocus (AF) which can maintain precise focus on objects moving in any direction. It will instantly adjust to abrupt changes in speed and direction, aggressively tracking the target during rapid acceleration and deceleration. A 16-bit microprocessor operating at a clock speed of 20MHz, along with improved data processing, enables the 700si to maintain focus on objects traveling as fast as 155mph (270km/h).

High Performance Autoexposure

The exposure system's silicon photocell is divided into a 14 segment honeycomb (multiple-zone) metering area. The processing programs use information from the AF system and the camera position sensor to identify the location of the primary subject in the frame. Even if it happens to be off-center, compensation for spot or backlighting is provided instantly.

The 700si uses "fuzzy logic" intelligence (defined later) to evaluate the type of scene being photographed. This, together with subject brightness, overall scene contrast, and the focal length in use, enables it to set the optimum exposure automatically. The system will recognize typical subject situations and set a suitable shutter speed/aperture combination in Program mode.

The intelligent system continues to monitor and control the exposure when using a Maxxum/Dynax flash unit, either as a main light or for fill lighting outdoors. Combine the 700si with the new Flash 5400HS, and the combination offers a feature available with no other Minolta camera: High Speed Synchronization to a full 1/8000 sec. HSS is selected automatically when a shutter speed over 1/200 sec. is in use.

Multi-Faceted Exposure Control

The Maxxum/Dynax 700si offers two exposure metering options besides evaluative: Center Weighted and spot metering. The first concentrates 80% of the meter's sensitivity into the central three segments, while the latter reads only a narrow 2.7% of the central image area. These options provide the experienced photographer with the flexibility to produce predictable exposures.

There is a wealth of subject matter which is often more suitable for a black and white rendition than a color reproduction depending on the effect desired. It is rewarding to explore both types of creative expression.

Particularly notable is the Metering Index scale in the viewfinder. Ranging in +/- 3 stops, the scale is a multi-purpose display which shows:

- the difference between a 14 segment Expert meter reading and a Center Weighted reading; this allows the user to determine what compensation has been applied by the system
- the amount of exposure compensation manually dialed in, as a reminder in Center Weighted Averaging
- the difference between a locked spot reading and, after recomposing, the brightness of the area now being metered; this allows the photographer to assess the brightness range of any scene as with an accessory spot meter
- the difference between manually-selected exposure settings and the camera suggested exposure in any metering pattern

Full Override Ability

All of the exposure control functions of the Maxxum/Dynax 700si are laid out so the photographer can change them in a split sec-

ond. Aperture or shutter speed can be shifted in Program mode without affecting the original exposure. Those who prefer the familiar methods can select Aperture Preferred, Shutter Preferred or fully Manual mode. Any of these work perfectly with all three exposure metering patterns.

Additional override is available through three options: exposure compensation in the +/- 3EV range, automatic exposure bracketing of three images (varying the exposure in 1/2 stop increments) and Flash Exposure Compensation which can be accessed on the 700si, making this amenity available with any dedicated flash unit.

Full Information Display

Relevant operating information is displayed in the viewfinder: some on the small panel below the screen, and some overlaid on the image area. The latter, called a graphic display viewfinder, is a transparent screen. Dyes are used to form the indicators which superimpose certain information over the image. The photographer is therefore constantly aware of what is going on without removing his eye from the camera. If the settings do not match your intentions, you can quickly and smoothly effect changes in focus, exposure, depth of field, and other creative factors.

Unlike some of its competitors, the 700si is equipped with a depth of field preview button, sure to please the serious photographer. At a touch, one can estimate the range of sharp focus, although the screen necessarily darkens as smaller apertures are selected. From landscapes to portraits, to macro photography, the ability to preview the effect will be greatly appreciated. The only drawback is that you must release the preview button before you can switch to other apertures.

Customizing The 700si

Of what value is the most advanced option if it takes too long to access while a situation is rapidly unfolding? The Maxxum/ Dynax 700si offers a Memory feature which enables the photographer to store frequently used camera settings. This includes all

important camera functions such as exposure mode, shutter speed and aperture, flash mode, compensation values, exposure metering mode, selected AF sensor, AE mode, film transport mode, etc.

For example, you could select the following personal values for portrait photography outdoors: Aperture Preferred mode at f/4.5, single frame film advance, Spot Metering, +1/2 stop compensation, top AF sensor only, focus priority AF. Record these settings by moving the memory switch to the [Enter] position (while holding the tiny unlock button). A touch of the [M] will then recall these values at any time, and they can be revised whenever desired using the sequence mentioned above.

The Maxxum/Dynax 700si has many other control and exposure mode options available through optional software chips called Creative Expansion Cards. These will be discussed in a later chapter.

Quiet and User-Friendly

The 700si's motorized film transport mechanism is noticeably quieter thanks to vibration and sound reduction precautions. The redesigned drive motor with its non-metal gears and rubber shock absorbers allows you to shoot discretely without disturbing your subjects.

The intelligently placed control dials and buttons make the 700si an accommodating camera. Many functions can be controlled without removing your eye from the viewfinder, where the smooth, neutral tone Accu-Matte screen offers a surprisingly bright, clear image. The high-eye-point viewfinder, designed for people who wear glasses, is an obvious asset. The long eye relief allows full viewing of the image and all displays up to 0.9" (22.9mm) from the rear protective glass.

The optional Vertical Control Grip VC-700 lets you hold and use the camera vertically with the same ease as in horizontal compositions. This grip includes a second set of all essential controls: shutter release button, two control dials, Spot button, AF button, and an ON/OF switch for the grip. As a bonus, there is a sync cord terminal for plugging in manual flash systems.

The VC-700 Grip powers all camera functions with a choice of

either lithium 6V (Type 2CR5), four 1.5V alkaline cells or four 1.2V rechargeable NiCds.

High Speed Sync (HSS) Flash

Mount one of the new Maxxum/Dynax Flash 5400HS High Speed Synchronization units and flash exposures are possible at any shutter speed right up to 1/8000 sec. with the 700si. You can take flash pictures automatically in all exposure modes, as the camera selects HSS at shutter speeds above 1/200 sec. Portrait photographers, for instance, will be able to use fill-flash in brilliant outdoor light, with wide apertures to defocus the backdrop, while maintaining a proper background exposure. The camera's X-sync speed is no longer a limiting factor.

The 5400HS triggers a short pre-burst in HSS mode as soon as the shutter release button is pressed. The 700si's honeycomb meter reads the reflected light and calculates appropriate flash intensity for a suitable balance of illumination between subject and background. At the high shutter speeds, the system delivers a series of high-frequency light pulses that simulate continuous light to evenly illuminate the entire subject as the focal plane shutter travels.

An additional new function of the 5400HS is a small, continuous light source that enables the photographer to preview the light and shadow relationships in the final image. This modeling light, as it's called, is especially useful with off camera flash for finding undesirable shadows and adjusting the position of the head before taking the picture.

In Multi-Burst mode, the 5400HS triggers a series of flashes (strobe) in close succession, allowing you to create a photographic study of a moving object.

In this chapter we have provided a brief overview of the most important functions and features of the 700si and 5400HS. Subsequent chapters will discuss how to use these features intelligently in practice.

First Encounter with the Maxxum 700si

If one wanted to describe the 700si in a few words, the following might come to mind: compact, ergonomically-contoured SLR with comfortable handling, easily-accessed controls, and incorporating the most advanced technology. The list of standard amenities reads like a "wish list" come true: Aperture and Shutter Priority AE, metered manual mode, shiftable intelligent Program mode, multi-point Omni-Dimensional autofocus, intelligent honeycomb metering pattern, center weighted and spot metering, autoexposure bracketing, a full complement of overrides including flash exposure compensation, ultra-sophisticated flash control, and so on.

This should suffice, although there are many more features listed elsewhere in this guide. So many options could lead to user frustration. In a worst-case scenario, it would lead to using only one mode - full Program. That would be a real shame because the vast range of creative options offered by the 700si would be wasted. One remedy against taking the easy way out is to read this guide which should help you learn how to use your 700si.

The camera's well-thought-out design helps to make this a painless process. Depending on the selected mode of operation, for example, the two control dials have different functions and the viewfinder display shows only the pertinent information. Each button has a single function, clearly marked for ease of use. Thankfully, all are logically placed, where your fingers naturally fall. Infrequently used controls are hidden behind the door to avoid confusion caused by too many visible buttons.

Taking Control

Although you can choose to rely totally on the expert intelligence built into the 700si, Minolta designers have incorporated every possible override for full creative control. The 700si is "interactive", providing full feedback on essential points: where it is focusing and how it is metering a scene, for example. Take the

Minolta Maxxum 700si - Graphic Display Viewfinder

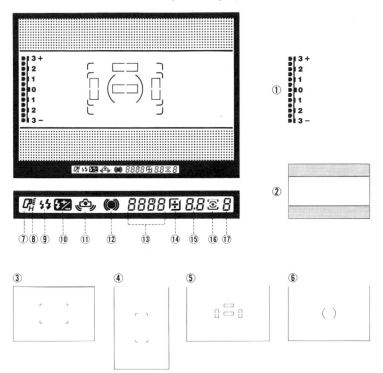

1. Metering Index
2. Panorama Indicator
3. Focus Area Indicator
4. Focus Area Indicator
5. Focus Area Indicator
6. Focus Area Indicator
7. Flash On Indicator
8. High Speed Sync Indicator
9. Flash Mode Indicator
10. Flash Compensation
11. Camera-Shake Warning
12. Focus Signals
13. Shutter Speed/Film Speed/Focus Area Display
14. Compensation Indicator
15. Compensation Display – Aperture/Exposure/Flash
16. Metering Mode Indicator
17. Frame Counter

shot or turn a dial to take over control. Pick an alternate point of focus or vary the exposure, with viewfinder readouts confirming your corrections.

The 700si, while logical to operate, requires study of the Owners' Manual following each of the instructions with camera in hand. It is a step by step course on using the 700si, essential for familiarizing yourself with all of the camera's options. So if you have yet to work with the instructions in order to become familiar with all camera controls and functions, do so before reading on. That way, we can concentrate on problem solving and explaining concepts, essential to maximize the value of any multi-mode SLR camera.

Predictable Exposures

If you would like to know the difference between the two metering methods - Expert honeycomb and Center Weighted - simply touch the exposure compensation [+/-] button when Expert metering is active. The exposure indicator scale in the viewfinder now displays the difference between the two readings. The zero reference point is the result of Center Weighted Averaging; the pointer denotes compensation added by honeycomb metering. This shows you how the 700si analyzes complex lighting patterns, so the end result is quite predictable.

You can determine how "intelligently" the honeycomb system reacts to back-lighting or an off-center highlight. If the subject is evenly illuminated, you will notice only moderate differences. With extreme lighting variations you will notice that the system has compensated intelligently — increasing exposure for a snow covered scene in brilliant sunshine, or optimizing exposure for a portrait subject instead of the bright background sky, for instance.

Panorama Frame Preview

If the [AF] and [CARD] buttons are simultaneously depressed while the camera is being turned on, a panorama frame appears in the viewfinder. You will discover the usefulness of the mask in a subsequent chapter on Accessories for the 700si. Even without

this device, you can preview the effect which would be created by a long narrow frame. (Turn the 700si off to revert to a standard screen).

The LCD Display Panel

Additional information as to the camera's operation can be found on the 700si's LCD (liquid crystal display) screen, called a "body data panel" by Minolta. A full 22 pieces of data can be checked, but only those which are relevant appear at any given moment; this prevents information overload. The symbols used are logical, but it is essential to learn to recognize the meaning of each, clearly explained in the Manual.

A very important piece of information concerns the battery capacity: the display changes as the time for replacement approaches. You can also determine if a film is loaded and, if so, how many exposures have already been made. The counter is active only when a film has been loaded.

The aperture and shutter speed can be checked, as can the mode in use: P = Program, S = Shutter Preferred, A = Aperture Preferred, M = Manual selection of aperture and shutter speed. Small symbols also indicate if the motor is in single exposure or continuous advance, which metering mode has been selected and whether the AF system is set for Focus- or Release-Priority (explained later).

There are many other reminders, assuring that the viewfinder and LCD display panel keep the photographer informed as to exactly what the camera is doing.

The Shutter

A metal focal plane shutter, running vertically, controls the Maxxum/Dynax 700si's exposures. Two metal blinds run from top to bottom, with exposure time determined by the space between them. The closer they follow each other, the smaller the opening through which the film is exposed. This enables very fast shutter speeds up to 1/8000 sec. with the 700si. The highest shutter speed is a function of the top speed of the blinds and the

smallest slit between the two. The top speed can be attained because the blinds travel down the short side of the film: they cover less distance than horizontal traverse shutters. The speed is

Minolta Maxxum 700si - Body Data Panel

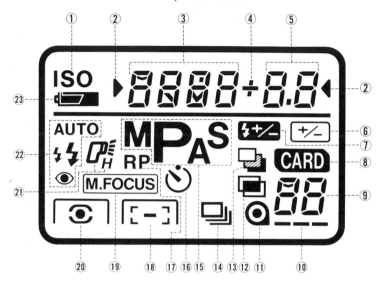

1. Film Speed Indicator
2. Selectable Setting Pointers
3. Shutter Speed/Film Speed/Card Name/Local Focus Area Display
4. Compensation Indication
5. Aperture/Exposure Compensation/Flash Compensation/Card Setting Display
6. Exposure Compensation
7. Flash Compensation
8. Card Indicator
9. Frame Counter
10. Film Transport Signal

11. Film Cartridge Mark
12. Double Exposure Indicator
13. Exposure Bracketing Indicator
14. Drive Mode Indicators
15. Exposure Mode Indicators
16. Self Timer Indicator
17. Release Priority Indicator
18. Wide/Local Focus Indicator
19. Manual Focus Indicator
20. Metering Mode Indicator
21. High Speed Flash Indicator
22. Flash Mode Indicators
23. Battery Condition

also created by the special blade design and ultra-light weight metal construction.

At the other end of the time scale, the 700si allows long exposures up to 30 sec. Timed exposures of any duration are possible in Manual mode: the shutter remains open as long as the trigger is depressed in the [bulb] setting, but without metering guidance.

Maintaining a consistent shutter speed during an exposure is of the utmost importance to guarantee that each portion of the film receives the same amount of light. Otherwise, a image with stripes of different illumination would result. The difficulties inherent in the construction become obvious if one considers that each curtain has to accelerate very quickly to top speed, travel at that speed across the entire frame, and then come to an abrupt stop. Given the inertia of the shutter components, it is impossible to attain an absolutely even speed over such a short distance. The width of the slit is therefore continuously being changed in order to guarantee an even exposure.

Afterwards, the shutter must be returned to its starting position in anticipation of the next exposure. This occurs immediately

The Maxxum/Dynax shutter is a masterpiece of electronic and mechanical design.

while the film is being advanced, allowing for 3 frames per second motor drive. By the way, take care not to touch the exposed surfaces of the shutter blades while loading film. They are very thin in order to reduce the amount of mass that has to be moved during high shutter speeds.

The longer exposure times are controlled through a delay in the rear shutter curtain. At an exposure time of 1/30 sec., for example, the first curtain opens the frame from bottom to top as

quickly as possible. The second curtain follows at exactly the same speed, 1/30 sec. later, also running from bottom to top. This means that those parts of the film that were exposed first are also covered first, creating a uniform 1/30 sec. exposure over the entire frame.

High Speed Flash Sync

If the second curtain moves slower, the slit gets wider and the exposure time increases. As exposure time increases, the slit becomes as wide as the film window itself: 24mm. At this particular speed (1/200 sec. with the 700si), the shutter exposes the entire frame at once. With most cameras this is also the highest speed that can be selected when using electronic flash units. That's because flash typically produces a brief, single burst. If the entire frame area is not open at this point, only a small slit will be exposed; a portion of the image will remain black.

The 5400HS flash unit, specially designed for the 700si, is an exception to this rule since all shutter speeds up to 1/8000s can be used. Additional information on this technology and its value will follow in subsequent chapters.

The Bayonet Mount

The bayonet mount has established itself as a faster but equally secure way of mounting the lens on the camera, in comparison with the older breech mount system. This mounting method has just about replaced all others simply because it is faster and more exact. See for yourself how short the throw is once the two red dots are lined up. It's barely a quarter turn, where screw mounts require several complete revolutions. And with this short turn, all control elements are securely coupled. Information must travel both from the camera to the lens as well as the other way around in order to facilitate the various program mode options. The Maxxum/Dynax cameras not only control the internal shutter speed in Program mode, but also the diaphragm and focus operation of the lens.

Gold-plated electronic contacts perform the actual data trans-

fer between lens and camera. Information concerning maximum aperture and focal length of the lens are transmitted to the camera body while the focus mechanism is driven by a motor located in the 700si.

The bayonet mount is therefore the most important connection element. Inaccurate alignment, in particular, can prove fatal. Camera and lens must fit together precisely to guarantee that the film and lens are perfectly parallel. If the data transmission elements do not make perfect contact, incorrect information, and hence incorrect exposures, would result. Minolta engineering and construction ensure maximum quality control so the 700si should be as reliable as its predecessors.

The Film Advance Motor

Control: *press and release the top button behind the card door; rotate either control dial to select single or continuous film advance, self timer, or double exposures.*

Depending on which advance mode you have selected, the 700si will either expose one frame or as many as three frames per second until the trigger is released or the film ends. This built-in motor is relatively fast with a maximum speed of 3 frames per second (fps). It is not one of the fastest available, but it is prefer able to many which manage only one or two frames per second. We have found that 3 fps is adequate for the vast majority of situations encountered by the amateur photographer.

Motorized film advance is certainly preferable to using an advance lever for transporting the film and cocking the shutter. The built-in motor means that the photographer will not miss that once-in-a-lifetime shot. With this feature, there is no risk of forgetting to advance the film, and missing the decisive moment. Motorized film transport replacing the manual lever is but one example of intelligent automation of previously mechanical functions.

Is a motor really necessary? We think so, since eliminating the need to advance the film after every frame makes action photography far more successful. In other pursuits, it means that the camera does not have to be removed from the eye. This leaves

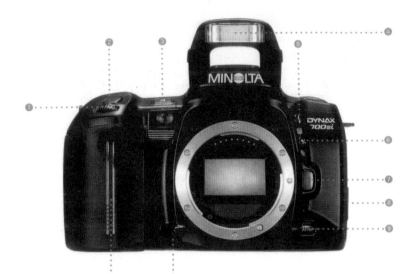

1. Front Control Dial
2. Shutter Release
3. AF Illuminator/Self Timer Indicator
4. Built-in Flash
5. Flash Control Button
6. Exposure Compensation Button
7. Lens Release
8. Rear Cover Release

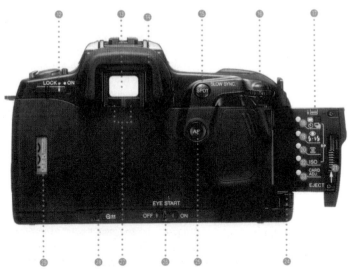

9. Focus Mode Button	23. Card Adjust Button
10. Depth of Field Preview Button	24. Remote Control Terminal
11. Grip Sensor	25. AF Button
12. Main Switch	26. Eye Start Switch
13. Long Eye-Relief Viewfinder	27. Eyepiece Sensor
14. Eyepiece Cup	28. Rewind Button
15. Spot Button	29. Film Window
16. Rear Control Dial	30. Exposure Mode Button
17. Card Door	31. Program Reset Button
18. Self Timer/Drive Mode Button	32. Card On/Off Button
19. Flash Mode Button	33. Body Data Panel
20. Metering Mode Button	34. Accessory Shoe
21. Card Eject Slide	35. Memory Switch Release
22. ISO Button	36. Memory Recall Button
	37. Memory Switch
	38. Strap Eyelet

the photographer free to concentrate on the situation and not on advancing the film. Combined with constantly looking through the viewfinder, you can now trip the shutter or shoot an entire series of frames in rapid succession. A motor significantly increases the odds of capturing the ideal moment, as it is much faster than any of us could ever hope to be.

Nonetheless, in spite of all its speed, it still cannot determine the perfect moment to take a picture. And shooting a long series of frames will not guarantee that you will capture the peak of action, as the following example demonstrates.

Let's assume that you want to capture a thoroughbred as he crosses the finish line with a 1/1000 sec. shutter speed. At three

fps, only a fraction of the second will be recorded on film. Hence, chances are slim that the right moment will occur during this tiny window in time. Even a long series of frames will not guarantee success, as you are still not recording every millisecond on film. This example confirms that a motor drive cannot replace waiting for precisely the right moment to trigger the camera.

For the best results, the reaction time between operator and camera has to be carefully timed to convert the thought (I want to take a picture now) into action (press the trigger). With some practice this becomes second nature, increasing your success ratio in action photography. This will be enhanced by the 700si's Omni-Dimensional Predictive Focus Control which will continue tracking the subject even at the full three fps.

Eye-Start Automation

Control: *turn EYE START on with the switch near the base of the camera's back panel.*

Normally, you have to activate an electronic camera after turning it on by lightly pressing the shutter release. Only then do the metering, focus and other systems begin their operation. In order to reduce this response time, the 7xi incorporates Eye-Start automation. Flip the switch to the On position and the 700si will be ready to respond as soon as you bring the camera to your eye.

The system recognizes that you may want to take a picture by relying on information from two sensors: one in the hand grip and the other in the viewfinder. The first recognizes pressure and the other the blockage at the finder. It makes sense to use two sensors since the probability of accidentally activating the camera would be high otherwise. When one of the two sensors no longer registers, the systems shut down after five seconds to avoid draining the battery.

As soon as you see a subject and raise the camera to take a picture, all settings are made instantly; the 700si is ready to shoot as soon as you have determined the appropriate composition. While Eye-Start is not an essential feature, it certainly comes in handy when recording spontaneous activity. By the way, the OFF

switch was provided for a valid reason. When carrying the camera in your hand, Eye-Start will be activated if the viewfinder is covered by a part of your body.

Self Timer

Control: *press and release the top button behind the card door; turn either control dial until the self-timer symbol appears in LCD panel.*

The self-timer is not only useful to include the photographer with his family on film, but can also be used for shake-free shutter release. This is very important in macro photography, for example, where long bellows or heavy lenses make for a less than stable combination. It can also be useful anytime with long exposures with a tripod, for vibration-free photography when a Remote Cord is not available.

Approximately ten seconds elapse between pressing the trigger and the actual exposure. A red light flashes on the front of the 700si during this interval. The function is deactivated after the picture is taken, and you can continue to photograph normally.

Hopefully, the logic behind controlling the 700si has become apparent by now, particularly for those who recently made the transition from a mechanical SLR. If you have not yet used your new camera, it's almost time to get out and begin shooting.

The Maxxum 400si

In January 1994, Minolta announced an addition to the **si**-system. This was the 400si, with fewer features but available at a substantially lower price. If you already own a 700si, consider its sibling as a backup body for use with another film type or as a second camera for your family. If you have purchased a 400si, do note that its technology is not identical to that of the 700si as it relies on the autofocus and autoexposure system originally designed for the Maxxum/Dynax 3xi and 5xi. Review our comments on the differences here and in the Introductory chapter for specifics.

Overview of the 400si

Both the first time SLR buyer and the experienced photographer will find this camera easy to operate, thanks to simplified, logical controls. At first glance, this seems to be a Program camera, with

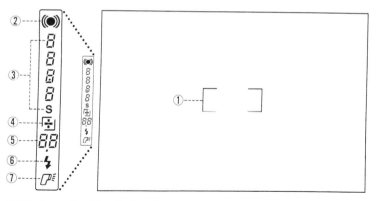

Full Information Viewfinder of the Minolta Maxxum 400si

1. **Focus Area Indicator**
1. **Focus Signals**
2. **Shutter Speed Display**
3. **Exposure Compensation Indicator**
4. **Aperture/Exposure Compensation Display**
5. **Flash Ready Indicator**
6. **Flash On Indicator**

settings for five diverse subject types. But then you notice the markings "A/S/M" and a [+/-] button. These denote Aperture and Shutter Preferred operations and full manual control plus exposure adjustment to ensure creative control. The above confirms that the 400si will meet many of the demands of the knowledgeable photographer with the overrides most expected.

The 400si accepts a broad variety of Minolta Maxxum/Dynax lenses and accessories, though not the Creative Expansion Cards or the VC-700 Grip. Unlike some cameras in this league, there is a full information viewfinder and LCD panel offering essential feedback on the settings in use. Besides the built-in head, Wireless off-camera capability is available with automatic ratio control, as with the 700si.

Subject Program Selection

The standard "P" mode makes taking snapshots a breeze, with Expert Program selection. "Fuzzy logic intelligence" analyzes motion, magnification, focal length, and subject type, responding with a suitable aperture/shutter speed combination. This cannot be varied, as with the 700si. Instead, Minolta provided "Subject Program Selection", a menu of five programs specifically suited to certain subject types.

Select Portrait, Landscape, Close-up, Sports Action or Night Portrait mode by turning the Command Switch to the program icon; then press the [MODE] button and turn the single control dial until reaching the desired Program. Intended to achieve effects most appropriate for the situation, all settings are made by the camera in these modes.

In the Landscape program, the system will maximize the range of sharp focus by selecting the smallest possible apertures while maintaining a hand-holdable shutter speed. On a bright sunny day, for instance, with ISO 100 film and an AF 28mm lens, it will select f/16 at 1/60 sec., achieving both goals. Use a wide focal length for the perspective most likely to enhance a landscape picture. Avoid using flash, as your subject will likely be well beyond its range.

Switch to the Portrait program and exactly the opposite occurs. The system selects wider apertures from f/1.7 to f/8, to blur away

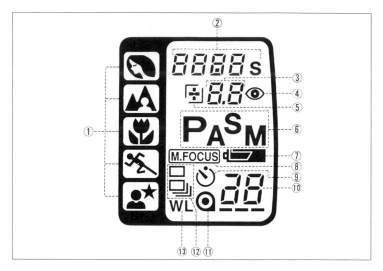

Body LCD Data Panel of the Minolta Maxxum 400si

1. Subject Program Indicators
2. Shutter Speed Display
3. Exposure Compensation Indicator
4. Aperture/Exposure Compensation Display
5. Red-Eye Reduction Indicator
6. Exposure Mode Indicator
7. Manual Focus Indicator
8. Battery Condition
9. Drive Mode Indicators
10. Self Timer Indicator
11. Wireless Remote Flash Indicator
12. Film Cartridge Mark
13. Frame Counter

a busy background. The larger the subject in the viewfinder, the smaller the aperture selected. This is necessary to ensure sufficient depth of field: for sharpness from the tip of the nose to the ears, for instance. Shutter speeds are generally high in such cases, although that is not the relevant factor in portraiture.

In Portrait mode, the best results are achieved with an 85mm to 200mm telephoto of wide aperture from f/1.4 to f/2.8. With a zoom lens, the maximum apertures are quite small at telephoto (often f/5.6) so the effect produced by this program is less noticeable. By the same token, the use of flash can also minimize the effect because a small aperture may be required for correct exposure. Use flash only in darkness or to soften shadows across your subject's face.

Close-up mode is designed for pictures of flowers and small

insects, taken with a lens with close focusing ability. The primary intent here is to keep the entire subject sharp, while blurring away a distracting background. Hence, the camera will automatically select f/5.6 for subject magnification of 1:4: one-quarter life-size, typical with macro zoom lenses. Switch to an AF Macro lens and the system stops down to maintain sufficient depth of field: to f/8 at 1/2 life-size magnification, and to f/11 for full life-size.

In Close-Up Mode, use an AF Macro lens or a zoom with "macro" and one of the supplementary close-up lenses mentioned in the Chapter on accessories. Mount the equipment on a tripod and trip the shutter with the self timer to allow vibrations to subside. The built-in or accessory flash unit should not be used if the subject is closer than 3.3' (1 meter) unless you add the new Close-up Flash Diffuser accessory. An exception to this rule is the Macro Flash Set 1200AF set, specifically designed for extreme close-up work.

In Sports Action mode, the 400si favors the higher shutter speeds, such as 1/1000 sec. in sunshine, while the autofocus system provides continuous AF. This combination will freeze motion blur effectively for maximum sharpness. For the highest possible shutter speeds, use a wide aperture lens such as an f/1.4 to 2.8. Except in brilliant sunshine, switch to an ISO 400 film. Use flash only for nearby subjects, when the light is too low for hand-held shooting. Select continuous film advance to capture an action sequence on a series of frames.

And finally, there's Night-Portrait mode, best used for people at twilight or at night with lights from a city or carnival in the background. If you're using flash, the 400si will set slow sync so the flash exposure is balanced with the background light. Expect a long shutter speed, from 2 seconds to 1/60 sec. (depending on the conditions) to allow time for the lights to register on film. The subject will be illuminated by flash while the surroundings will be pleasantly rendered as well. Use a tripod to avoid motion blur unless that is the intended effect.

If you do not use flash in Night Portrait mode, the scene will be exposed according to the ambient light level. We recommend this for cityscapes at night, for exposures as long as four seconds. Manual focus is often required, as it's usually too dark for the AF system. A tripod is essential, of course, unless you're after some special effect.

Drive Mode/Self Timer Button

Mode Button

Built-in Flash

Shutter Release

Control Dial

Self Timer Light

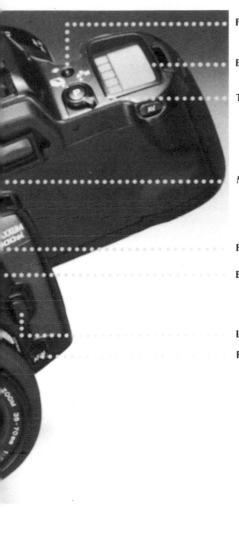

Flash Mode Button

Body Data Panel

Three-Way Selector

Main Switch

Flash Control Button

Exposure Compensation Button

Lens Release

Focus Mode Button

Evaluation of Subject Program Modes

These programmed modes will certainly produce the types of pictures most people expect given the subject type. But remember that hand-holdable shutter speeds are prioritized by the system (with all but the latter). Consequently, in heavily overcast conditions, this factor tends to take precedence over the creative considerations. Use an ISO 400 film in such cases to take advantage of the most suitable combination of apertures and shutter speeds.

The system takes focal length and magnification into consideration as well, so the results will differ depending on the lens and distance from the subject. This is a logical approach, since these factors would affect the experienced photographer's choices as well.

Perhaps the only criticism is a creative one. Consider the Sports Action program, for instance. While freezing a soap box derby car on film with a 1/1000 sec. shutter speed may sound reasonable, the end result may not be the most satisfying. In some cases, we'd want to use a longer shutter speed, perhaps 1/30 sec. with a 200mm lens, and then pan with the subject - so speed blur, especially on the background, simulates the effect of motion.

And you may prefer extensive depth of field in an environmental portrait. Granted, you can select the Landscape mode and the displays will confirm that a smaller aperture has been selected. Now, longer shutter speeds will result, as well, so you could also use this program to blur the derby track effectively.

That is a valid approach, one we would use with a camera which offered no other options. But we'd still be at the mercy of the system, which selected f/11 at 1/125 sec. instead of f/16 at 1/60 sec., for instance. So these Program Selection modes are still less than ideal in thoughtful work. Nonetheless, when getting an image on film is more important than the exact settings, the programs deserve consideration. Thankfully, Minolta also offers the other options for the serious photographer who insists on greater personal control.

Semi-Automatic Modes

Just like the Maxxum/Dynax 700si, the 400si includes both Aperture Preferred and Shutter Preferred modes. Now you can set

exactly the aperture, or shutter speed, desired in half stop increments and explore the effects of depth of field and motion. Move the Command Switch to A/S/M and press the [MODE] button; turn the single control dial until the desired mode is displayed on the data panel.

The experienced photographer will find this preferable to flipping from one Program to another in hope of an ideal combination of f/stop and shutter speed. You can select just the right aperture in A mode or the best shutter speed in S mode in 1/2 stop increments. The system will respond with the other setting to ensure appropriate exposure, relying on the honeycomb pattern metering system.

When you decide to over- or underexpose intentionally, dial in exposure compensation in 1/2 stop increments. Press and hold the [+/-] button and turn the control dial until the desired value is displayed. perhaps +1 for a snowy scene, which should be rendered pure white.

Metered Manual Mode

Follow the same procedure to access fully manual mode (M) if you want to work without automatic assist. Although the 400si does not include a Metering Index Scale, a "+" symbol warns of over exposure and a "-" symbol of underexposure. When you reach an appropriate combination, a "+/-" symbol appears in the viewfinder, confirming that your choice agrees with the Expert metering system. Note that we did not say "correct exposure" because the computer cannot predict the effect you specifically want to achieve.

So ignore the "+" or "-" warning and use your own judgment, intentionally underexposing a black stallion to render it as richly dark, for example. Since the display does not specifically denote the amount of deviation from the camera-recommended exposure, you'll need to count the clicks of the control dial. Each click designates a 1/2 stop increment toward over-, or under-exposure from the system recommended readings. Because the 400si includes only a single dial, you'll need to press the [AV] button (denoting "aperture value") to shift f/stops with the dial. Release it and the dial will control the shutter speeds instead. This is similar

to the Manual operation of some earlier Maxxum/Dynax cameras, and has proven to be simple and logical.

Exposure Metering with the 400si

Now we move into some substantial differences between the two cameras. Most notable is the absence of Spot and Center Weighted metering patterns. Some will miss these options while others will come to realize that the 8 segment honeycomb evaluative system is quite effective in many circumstances. It is not quite as sophisticated as the Expert 700si system, having been designed for the 3xi/5xi. But it has proven quite useful in 75% of common shooting conditions, down to EV 1, the light level in a fairly dark room.

Refer to the Chapter covering substitute metering and other strategies surveyed with the 700si, remembering that you do not have all the options such as the Metering Index Scale and the other two patterns. But you do have Auto exposure Lock – simply maintain light pressure on the shutter release button when re-composing and the 400si will hold the meter reading.

The multi-zone system includes seven central segments in a honeycomb pattern, and an eighth which covers the surrounding area. As such, it is more heavily center weighted than that of the 700si. This is actually an advantage in backlighting, where the background has less impact on exposure. If your subjects are frequently off-center, AE Lock becomes particularly useful. Start by centering the subject and then re-frame; maintain light pressure on the trigger to lock the exposure reading (and focus). Then recompose in accordance with the Rule of Thirds, for example, and take the picture. This process is simple and quick and will become intuitive after a few weeks of shooting.

The honeycomb-pattern metering measures exposure levels in all eight of the separate picture areas, always favoring correct exposure for the subject instead of the background. The uniform size and shape of the segments allows the meter to match numerous subject types, as proven with the Maxxum/Dynax 5xi previously. However, like any computerized camera, the 400si is not totally foolproof, especially with subjects of particularly high, and low, reflectance. And your creative intention may not be "accu-

rate" exposure in any event. This is why the 400si offers the overrides mentioned earlier.

Autofocus System

As expected, given the price differential, the predictive AF system of the 400si is less versatile than that of the 700si, as it originated in the 3xi. But it will still produce sharply focused pictures in the vast majority of circumstances typically encountered: in travel, team sports, and family photos. Since these subjects comprise perhaps 90% of the pictures taken today, we'd say that this Minolta will satisfy most owners of the new 400si.

In fact, the AF system will maintain continuous focus even on fast moving subjects such as children at play or the running back evading a tackle. Predictive AF is automatically activated by the camera when it detects motion (we explained this technology earlier). Minolta specs indicate that it can track motion at 22mph (37km/h) when subject magnification is 1/50th of life-size, which is common in action photography. The AF system is of the "focus priority type; the shutter will not release until focus is confirmed. This may limit your choice somewhat but will help to prevent unsharp pictures, a primary goal in most types of photography.

With still subjects, you'll often want to recompose with focus locked, because the single AF detection sensor is located in the center of the viewfinder. Light pressure on the shutter release allows you to do so, also locking exposure for the point in sharp focus. A logical approach, since we generally want the subject, and not the background, nicely exposed. (Naturally, AF Lock does not operate in Continuous autofocus since this would preclude the ability to follow focus).

The AF sensitivity range runs from -1 EV to 18 EV so the system will find focus even in light inadequate for manual focusing. In darkness, raise the flash head and it will automatically fire a short burst allowing the camera to detect and set focus on your subject. The 400si does not project a pattern to aid focusing, so you may wish to switch to manual focus with subjects of low contrast, or lacking in detail, such as a plain wall.

Film Transport

Like most cameras today, the 400si incorporates auto film loading, making this chore child's play. The one frame per second film advance is automatic, so you need not remove the camera from eye level. It can be set for Continuous advance if desired, as in action photography when you want to shoot a series of frames. Otherwise, it will fire once each time you depress the shutter release button. To switch between the two, use the Drive Mode button as explained in the owner's manual.

This control also allows for self-timer to be selected, ideal for tripping the shutter without vibration when working with a tripod. The ten second delay also allows you to get into the picture when desired; after one frame the camera reverts to normal operation.

Film speed setting is completely automatic, understandable since most every film type includes the necessary DX coding on the cartridge. Although there is no ISO dial which could be used to intentionally overexpose print film, for example, the [+/-] button can be used to achieve exactly the same effect. We like to shoot ISO 400 (and faster) color print film at a +.5 setting to increase color saturation and minimize grain for superior image quality.

Flash Exposures

The 400si incorporates a built-in flash head which can be raised by hand anytime it is required; recycle time is a quick 2 seconds (approximately). Coverage is provided for lenses as wide as 28mm. You can expect proper exposure both in automatic fill flash outdoors and in indoor photography. After taking the picture, the lightning bolt symbol in the viewfinder will flash if output was sufficient for correct exposure. If not, move closer or switch to a higher ISO film.

As long as the subject is within flash range, your pictures will be pleasing. Naturally, the range varies depending on the level of darkness, the level of reflectance of the subject and surroundings, film speed, focal length, maximum aperture of the lens, etc. With an AF zoom lens at 80mm and ISO 100 film, you can expect a range of at least 7' (roughly 3 meters), quite adequate in rooms typically found in most homes. We like to use an ISO 400 film

when shooting in low light, since the extra film sensitivity allows for up to double the distance range.

Whether the subject is backlit or in the dark, the system will recognize the situation, providing a hint of fill-in lighting or full illumination as is warranted. In dark conditions, red-eye is very likely with a built-in flash, as explained in the chapter on flash. Use the Red-Eye Reduction mode to produce a series of four pre-flashes, and brighten the room as much as possible to minimize the risk of a ghoulish effect.

In extremely bright conditions, such as at the beach or in winter, you'll notice hard shadows on and around the subject. In such cases, use flash to fill in the shadows for a more pleasing look. In A, S, and M mode, flash fires every time as long as the built-in head is raised or an accessory unit is activated. In Program mode, press and hold the flash control button while taking the picture (for "forced flash").

Wireless Off-Camera Flash

If you frequently take indoor flash pictures, you'll want one of the dedicated accessory flash units. The 400si is fully compatible with all i- and xi-Series flash units; older Maxxum models require the FS-1000 accessory. You'll appreciate their greater power, the ability to bounce light from a ceiling (with some models), or the ability to use a light modifying device. On-camera flash can produce highly acceptable results with one of these tactics, but for more advanced effects you'll need to remove the flash unit from the 400si.

One of the keys to creative photography is experimenting with light. Wireless/remote flash offers the flexibility for off-camera flash without a sync cord or TTL extension cable. Simply hold a 3500xi, 5400xi or 5400HS flash unit where desired, perhaps above the subject and at a 90 degree angle. Press and hold the flash control button while taking the picture and the remote unit will provide 2/3 of the illumination. Thanks to ratio control (2:1 to be exact), the smaller head provides the remaining 1/3, for an effect which proves most appropriate in people pictures, in particular.

The 400si's TTL (through the lens) exposure control assures accurate results; a "stop" signal is sent when the meter detects

that sufficient exposure has been received. Note that in Wireless mode, 1/45 sec. is the highest sync speed. Because the signal which activates the off-camera flash is a small burst of light, reduce the brightness of the surroundings as much as possible.

With some of the large advanced flash units some additional control is possible, though not High Speed Sync with the 400si/5400HS. If you want the extra versatility, check with your Minolta dealer as to which Maxxum/Dynax flash unit will best meet your needs. We particularly appreciate the 5400HS for its Modeling Light feature (explained in the Chapter on Flash). If you don't plan to do much formal work with flash, however, the equally powerful 5400xi will be most satisfactory. Many will get by very nicely with one of the smaller, more compact Maxxum/Dynax models.

Evaluation of the 400si

After examining a pre-production sample and reviewing Minolta documentation on the 400si, we were both impressed and disappointed. Impressed, because this appears to be a successful camera which will satisfy the snapshooter and the budding novice, while allowing even the advanced amateur to achieve many creative effects. Disappointed only in comparison to the 700si which is one of the most full-featured and technically sophisticated SLR cameras on the market.

When scanning the specifications of the two cameras back to back, you will note that those of the 700si are far more comprehensive. But comparisons of this type, motivated by intoxication with the sheer number of features, are both unfair and unnecessary. Just as we would not compare a luxury car with its budget-priced counterpart, we should not pit the 700si against the 400si.

Although the price of the latter is substantially less, it remains high on the price/value scale. This mid-range model does incorporate most of the desirable features we have come to expect, with many useful automated capabilities plus all the essential overrides. Both as an entry level SLR and as an additional body for a Maxxum/Dynax system, the 400si should offer years of reliable service in a broad range of photographic situations.

Great Pictures with Your si Camera

In this chapter we will discuss preparing the Maxxum/Dynax 700si, using the camera quickly and easily, and accessing the "Expert" Programs on the for taking good pictures. The latter is intended not only for the newcomer to photography with the 700si, but also for the experienced reader who occasionally want to shoot quickly with a minimum of decision making. Many sections of this chapter also apply to using the 400si and should be read by the 400si owner.

Power Supply

In order to ensure that the 400si and 700si will operate, power from batteries is a prerequisite. Many years ago, the first automatic cameras had exposure metering that was dependent on electrical current. Electronic control of shutter speeds was developed a short time later, making this function equally dependent on a power source. Some became frustrated when their cameras became useless due to battery failure, so many cameras included a mechanical shutter speed which would work under any circumstances.

The si-series cameras, like most of today's SLRs, are fully power dependent - just like your home computer. Absolutely nothing works with a dead battery, and the camera becomes a costly paper weight. This, however, is not as great a disadvantage as one might initially suggest. After all, what use is a functioning shutter (especially at a single speed) when the other essential functions are dead? Besides, no one demands that cars incorporate a hand crank in case the vehicle's battery gives up the ghost.

Obviously, prevention is the key to avoiding frustration with the 400si and 700si. For a few dollars, you can obtain the most dependable power insurance imaginable at your local photo retailer: a spare battery. And with the optional VC-700 grip (700si), the power source can be a set of rechargeable NiCds, an economical alternative to lithium and alkalines in the long run. Once fresh batteries are installed, everything operates as it

The Maxxum/Dynax Expert system can sometimes replace the photographer's expertise. Thanks to fuzzy logic, the 700si recognizes many subject situations and optimizes shutter speeds and apertures for a pleasing rendition.

should, which is preferable (in our view) to a backup mechanical shutter speed.

Hint: *The battery is an integral part of virtually every current camera. Remove it from the camera when not planning to shoot for over a week, storing it in a cool place. This will reduce spontaneous discharge to a minimum.*

A single 2CR5 lithium battery suffices to operate all camera functions. It supplies the microprocessors and the motors in both the camera and xi lenses - for powered focusing and zooming functions. The battery is installed in the lower right side of the camera body but is removed when the VC-700 (with its own power source) is mounted with the 700si. A 2CR5 is relatively expensive, but compared to other options (alkalines, NiCds, etc.), a lithium cell offers the best energy to weight/size ratio. It is also relatively resistant to cold and quite capable of moving large masses, as when focusing zoom lenses with their numerous glass elements.

Film Handling Mechanism

After making sure that you do not currently have a film loaded, open the back cover and examine all the components. One feature the user learns to value is the semi-automatic film load function. No longer does the film have to be carefully threaded onto a take-up spool. Simply extend the leader to the mark, close the back, and let the camera take care of the rest.

But first, take a look around the inside of the camera a bit longer. Inside the door is a spring loaded stage called the pressure plate. Combined with the two gleaming film tracks which are ground to extreme smoothness, this device ensures that the film is perfectly flat during the exposure. This is critical since a deviation of only a hundredth of a millimeter is sufficient to jeopardize even focus over the image area.

The Appropriate Film Type

An integral part of creating effective photographs is the film we load but photos are often made without consideration of the type, speed or specific advantages of a certain film. Yet, the widely diverse subjects we photograph will vary dramatically, so a film which is perfect for one may well be inappropriate for another.

Although color negative films are clearly the preferred choice if you want only prints, many appreciate the three dimensional brilliance of a projected slide. Also, the latter is preferred for publication in books and magazines because the color separations required to transfer the image to the printed page are still most effectively made from a positive transparency.

Otherwise, each type has its own set of advantages. The slide versus negative debate very seldom comes to a definitive conclusion. A hybrid would be really ideal. Respooled motion picture film which is used to produce either a slide or a negative, or both, does exist and is often advertised in photo magazines. However, given the superior quality of the brand name films, the popularity of this type has waned.

Choosing a film depends on many variables. Product photography, for example, usually demands superior resolution of fine detail so a "slow" film (ISO 25-64) is the most appropriate choice.

Film Selection Criteria

Let's begin with generalities when considering other criteria. The most important consideration is the sensitivity, upon which grain and sharpness are dependent. The photographer has to decide which characteristics are most important and load the corresponding film before he takes his shot. If a sharp, fine-grained image is critical, a slow film around ISO 25 to 64 should be selected and a tripod or flash used if the shutter speeds are too long.

But if you want to hand-hold the 700si in dim light, or decide to stop motion, use a higher speed film from about ISO 400 to 1000 to take advantage of faster shutter speeds. The coarser grain of this type of film is a fact of life, but these days it's far less noticeable than with the films of an earlier era. In truth, a compromise is often the best course of action: film around ISO 100 to

High speed films (e.g. Ektachrome Elite 400) are used primarily for ⇨ hand-held shots in low light conditions. Although grain is less fine than with a slow film, this characteristic can be used to creative advantage, especially with even faster films of ISO 1000 to 3200.

200 is adequately fine-grained and sharp for a at least an 8x12 print or for projection. More importantly, they're still adequately "fast" to permit hand holding the camera, using flash if necessary.

We never leave home without a variety of films from the low, medium and high sensitivity ranges - the latter for fast shutter speeds at a night game, or interiors where flash and tripod are prohibited. Suitably equipped, we can shoot a broad variety of subject matter in diverse conditions and get high quality images.

If extreme sharpness and resolution (with minimal graininess) is your primary concern, select one of the slow films (up to ISO 100). The Kodak Ektar films, Agfacolor Ultra, Konica Impressa, and Fuji Reala or Super G print films are a suitable starting point. In color slides, the new Ektachrome Elite or Lumiere (Panther), Agfachrome RS Plus, Kodachrome 25, and the Fujichromes (especially Velvia) are sure to please the demanding photographer. But the choice of film is subjective in many respects, so experiment with several brands until settling on your final choices.

When considering the various brands of color print films, remember this: a good lab is far more important than the manufacturer. All popular brands will produce prints which range from highly acceptable to exceptional. With shoddy printing however, even the finest film will produce prints suitable only for lining the bird cage. Slide films, on the other hand, show significant differences in color balance and saturation. Here you will need to experiment (or at least read test reports in photo magazines) in order to narrow down the choices.

Hint: Films are best stored in cool surroundings to prolong their life. In summer, the refrigerator will generally suffice. But if the film is fast approaching its expiration date, the freezer is better for long term storage to prevent further aging. Before use, however, it needs time to acclimatize for an hour in warm conditions in its plastic canister in order to prevent condensation from forming on the cold emulsion.

Exposure Factors

If exposure were the only factor, the choice would be clear: color negative film would be the only option since, unlike positive film,

it has a broad exposure range. Exposure metering is not as critical as with slides since corrections can be made at the time of printing. But this is not completely irrelevant; optimal results are still obtained with accurate exposure. When in doubt, it is better to overexpose color negative films by one third to one half stop. For example, set the ISO to 320 with an ISO 400 print film; to shed grain, increase color saturation and provide superior detail in the negative.

Modern print films have such a wide latitude that the same roll can be exposed using different settings without special developing procedures. At any rate, you may be surprised by the amount of exposure error which can be corrected in printing — typically two stops under and two stops over exposure will still produce printable negs. The sophisticated honeycomb metering system of the Maxxum 700si will just about guarantee perfect negatives in a broad range of lighting conditions.

Slide films, on the other hand, demand very accurate exposure metering since they have a very narrow tolerance for error. As we'll see in Chapter 6, this is where the Expert capabilities of the 700si will be especially appreciated. Automatic exposure bracketing can also be used to vary the effect from frame to frame in 1/2 stop increments – which would be virtually indistinguishable in prints.

Even with subjects of moderate contrast (1:125 or 6 stops), slide film will tolerate an absolute maximum of one stop deviation. Highly contrasty scenes - with brilliant highlights and deep shadows - will produce problems even with the accurate honeycomb meter of the 700si. Either shadow detail or highlight detail will be lost, rendered as murky or "burned out," with the brightest areas producing a completely transparent area on the slide. Since such blown-out highlights are less pleasing than loss of shadow detail, slide films are usually exposed for the highlights.

Fortunately, the honeycomb metering system of the Maxxum 700si was designed to meter for the highlights. If spot metering, however, take your reading from a mid tone in a moderately bright area as opposed to one in the shade when shooting outdoors in contrasty light. With color (or b&w) print film, take the opposite approach; excessively bright areas can be printed down if necessary.

Assessing Your Images

Even though slide film has earned few credits so far, its value becomes apparent when photographic results are being judged. You can immediately determine the quality of the original without making prints by using a slide viewer or, even better, a light table and high quality magnifying loupe.

A good 4x to 8x loupe is ideal for judging 35mm slides and a light table offers convenience. Toss out those which are unsharp or otherwise flawed. Then, project only the very best for an audience or have your lab transfer them to a Kodak Photo CD for viewing on a T.V. screen. We still prefer projection as there is no other method for displaying our work in large format for an appreciative audience.

Unfortunately, a slide does not readily lend itself to much manipulation. If it is destined for projection, there are few correction options. An unpleasant color cast or incorrect exposure can be improved with professional duplication or computerized enhancement. Commercial sources for such work are few and the charges can be high. Suitable slide duplicating equipment with filtration control is readily available but is too expensive for all but the most dedicated. Hence, accurate exposure and the use of necessary filters (as with fluorescent lighting) should be considered a prerequisite when shooting slide film.

In the event of composition errors, you do have a couple of options. Try flipping the slide - the reversed image may well be more pleasing when projected. Or ask a well stocked photo retailer for cropping mounts with various sizes of openings from panoramic to square, for example. Naturally, if you make or order prints from your slides, cropping to improve the composition is a viable alternative. However, if the exposure is incorrect, even a skilled printer can offer little improvement.

Assessing Your Film Lab

Thanks to advanced technology today's color negative films are truly exceptional; far superior, even, to those produced three years ago. These improved versions produce sharp, fine-grained and nicely exposed images with bright and snappy colors. Of

This photo is less than impressive, but is used to illustrate the wide exposure latitude of today's negative films. The powerful studio flash failed to fire for this exposure, so the subject was recorded with ambient light alone. It's hopelessly underexposed, and yet, the negative and print still contain recognizable detail.

A – page 61

Available light photography is an excellent way to convey the mood of a scene. The increased grain of the film adds softness and thus, another creative element. For this shot, the photographer used a fast fixed-focal length lens. A slower zoom lens could have been used but would have required the use of a tripod.

B1, 2 – C1,2 – page 62-63

In or out of focus? Sharp or soft focus?

Sometimes images are created that are intentionally out of focus. However, this effect must appear intentional otherwise it will be regarded as a mistake. These four studies illustrate various ways that focus control can be used creatively.

D1,2 – page 64

There's always an exception to the rule.

Generally, wide angle lenses are not considered to be good for portraits. However, if a special point of view or emphasis is required, a wide angle lens may fit the bill. In addition, interesting effects such as the curved horizon line will often enhance the overall presentation of the subject matter.

B1

B2

C1

C2

D1

D2

F1

F2

E – page 65
Light and color control are essential elements in landscape photography
Choosing the right time of day to take the photograph can make all of
the difference.

F 1,2 – G 1,2 – page 66-67
Many photographic opportunities exist in common, everyday objects
and scenes. Keep an eye open for interesting subjects such as these.

H – page 68
Good photos seem to always have one thing in common regardless of
the subject, the interesting combination of light and mood.

course this presumes that prints are made to manufacturers' specs, and that's a presumption one cannot always make.

If you have been working with the 700si, the odds are in your favor. Focus and exposure should be dead on in most cases, so an excellent print should be expected every time. If your lab produces disappointing results, take a strip of negatives to the competition and compare the final results. Remember that color problems are rarely the fault of the photographer or the negative, except in unusual lighting conditions (e.g. fluorescent lights call for a magenta FL filter). The best labs offer custom enlargements, precise color and exposure correction as well as a choice of papers. While the cost may be slightly higher, the additional investment is worthwhile, in our estimation, for prints we plan to sell or display.

In contrast to the negative which is specifically designed for enlargements, a slide is intended for projection. Hence your mini-lab cannot automatically produce good prints from every slide. We recommend dealing with those who specialize in the process to avoid disappointment. Even then, you'll find that printing paper has a much more limited tonal range than the positive film. Solid shadows and/or burnt-out highlights can be expected when printing a contrasty slide unless specific precautions are taken.

Better Prints from Slides

Fortunately, custom labs can improve the results by pre-flashing the paper to hold highlight detail or making a "contrast mask" - an out of focus negative which is sandwiched with the slide when printing. A simpler alternative to the latter is to use a low contrast paper specifically designed for printing from a positive: such as Fujichrome SG with its softer gradations. If the slide is not overly contrasty, excellent enlargements are possible. Unfortunately, the most impressive slides - those of outstanding brilliance and stunning color and contrast - make disappointing prints without substantial expertise.

If your slides are not overly contrasty, consider ordering Ilfochrome Classic (previously called Cibachrome) prints. These can be quite beautiful with exceptional sharpness, bright and glowing, with deep, vibrant colors. If you're after the sharpest prints

with more striking color rendition, you may actually prefer slides printed on Ilfochrome to negatives printed with any other process. Ilfochrome enlargements are also highly fade-resistant, a valuable benefit if you plan to market your prints.

Some still prefer the tried and true method of printing from slides: making a copy negative with low contrast film specifically intended for this purpose. Any experienced printer can then manipulate contrast, exposure, tone and color using familiar materials and skills. To get the best results insist on a large internegative - from 70mm to 4x5" on film designed for this application. Otherwise, grain will be noticeable and sharpness will deteriorate substantially if the enlargement is made from a small, second-generation original.

Hybrid printing systems that combine the conventional chemical process with electronic image manipulation show promise in printing from slides. The original is converted into electronic information using a scanner. The signals can be viewed on a monitor and modified using mathematical relationships. The electronic image is then converted back into optical form with the help of a cathode ray tube and printed. It is possible to manipulate the original so it can be printed on color negative paper.

This service is already being offered in Europe as "Agfa Digiprint." Even old slides whose colors have faded can be noticeably enhanced in this manner. A 3x5 print costs only a little more than a conventional one, but the effective limit for a satisfying print is 8x10 because the cathode ray tube exposes fine lines on the image which are visible in larger prints.

Hint: *When selecting slides to print, don't use a projector. A paper print cannot reproduce the contrast range visible in projection. Hold the slide in front of an evenly illuminated piece of paper to determine how it will look once printed.*

This brings us to the end of this brief review of color film types. But for avid photographers this should be only the beginning of the search for the right films to record the essence of the multitude of possible subjects. (Because of limited space, we have not mentioned b&w films, since these account for less than 5% of sales).

Eventually, technology may reach a stage where a single film can be exposed anywhere from ISO 25 to 3200. This "super film"

will offer exceptionally fine grain plus a kaleidoscope of colors to please every individual taste. However, until that day comes, there will be many "best" films. Comparisons will remain meaningless until you discover your own preferences among the vast palette of colors all waiting to be explored.

Film Transport Functions

Loading film into the Dynax/Maxxum 700si is an exercise in simplicity. Merely pull the leader to the mark and close the door. The motor draws and spools the film all by itself as soon as you turn the camera on.

In order to ensure successful loading, extend the leader to the mark. Make sure it lies flat precisely in the guides. The film transport mechanism takes over when the back is closed and advances to the first frame. If the camera is not on, nothing will happen until you flip the switch to activate the 700si.

The 700si also sets the film speed while it is loading the film. This is critical for accurate exposure metering. Most films have a black/silver checker board pattern (bar graph) printed on their side which encodes the film speed, the "DX code". The 700si reads this information via contacts in the camera body and recognizes the film's sensitivity in the range of ISO 25 to ISO 5000.

It is always possible to change the camera selected film speed. Simply press the ISO button behind the door and select the desired sensitivity by turning one of the control dials. Manual selection is available from ISO 6 to 6400. Since any camera can occasionally make an error reading the DX code (especially if the cartridge is scratched), it's prudent to double check the setting by pressing the ISO button.

The film window can be seen on the back of the camera. Here you can not only determine if a film is loaded but also identify the type and speed. If your memory fails, this check can be a useful reminder.

Rewind is activated automatically by the camera after the last frame. After rewind, the film symbol flashes on the LCD panel. Should you decide to rewind in mid-roll, press the small button on the back of the body - twice for high speed rewind at the risk of extra noise. If the symbol fails to appear, the batteries are dead

(insert new ones) or some other problem has occurred. If this does not restart the camera (a highly unlikely occurrence), try this: open the back in complete darkness (in a closet, perhaps) to remove the film.

The 700si (like most current cameras) will wind the film into the cartridge completely. This will not create a problem if you're taking the exposed roll to a lab for processing. If you frequently rewind in mid-roll, however, purchase the appropriate gadget to retrieve the leader from a well stocked photo retailer. Another alternative is the CUSTOM xi Expansion Card which can be used to program the 700si to leave the leader sticking out of the cartridge for future rolls.

Hint: If you reload a partially exposed roll at a later date, it is prudent to advance the film at least one frame beyond the last used image. This will preclude the possibility of overlapping pictures. In order to do this, select Manual exposure, a 1/8000 sec. shutter speed and the largest f/number (e.g. f/22). Now shoot the required number of frames with the lens cap on and in the shade, with the viewfinder window covered.

The 700si is set to a slow, quiet film transport by the factory. If you prefer the film to be loaded and rewound twice as fast (with greater noise level), slide the main switch from LOCK to ON while pressing the top button inside the card door. Restoring the original setting is logically done in exactly the same manner.

Expert Exposure Control

Control: Press and release the middle button inside the card door; turn either control dial until a rectangle with circle and dot appears on the LCD panel. Honeycomb Pattern metering is the standard setting and is reactivated when the program reset button [P] is pressed.

The 700si's Expert system starts with the proven autofocus integrated metering computer first seen in the 7xi. Input from the camera's position sensor is used to help judge the orientation of the scene while improved algorithms are employed. This results

Maxxum 700si Honeycomb Pattern Metering

The 700si features honeycomb pattern metering which accurately evaluates 14 distinct areas of the picture. These include the 13 honeycomb segments shown, plus the background.

in improved exposure of backlit landscapes with bright skies and small subjects.

In order to make the reading as accurate as possible, Minolta uses a multiple zone honeycomb-pattern metering system for the 700si. The cell is divided into 14 segments – 13 in the array plus a background segment which constitutes the remainder of the viewfinder field.

Because of the uniform size of each segment, this system is capable of precise metering and exposure control. As the individual segments and reading patterns are symmetrical, slight movement of the subject will cause little change in measured brightness. This prevents a major shift in exposure which might lead to metering error.

When evaluating a scene, the camera's electronics will assess the subject's contrast characteristics and compare them with internally stored data. The result of this "situation analysis" determines whether the subject has high contrast ratio, if there is a back light situation, if fill flash is required, if exposure compensation is required for a brilliantly white subject, etc. Depending on the mode in use, the appropriate shutter speed/aperture combination is selected. If flash is being used, it is triggered as either fill or as the main light, depending on which is deemed more appropriate under the circumstances.

This multi-zone metering is highly dependable and there are few situations that the 700si cannot successfully handle. When

shooting landscape pictures, the position of the sky is established and the exposure algorithm ignores this overly bright area to prevent underexposure of the foreground. Whenever the camera judges a scene to be a landscape, the center and lower segments of the honeycomb pattern are weighted.

Exposure of backlit subjects is also improved over previous Maxxum/Dynax models. The 700si uses input from the position sensor to determine whether this is a vertical or horizontal composition. Then it is able to locate the probable subject and compare the brightness ratio (between the target and its surroundings). This decision is made based on brightness information obtained from the background reading honeycomb segments, producing better subject exposure.

Note: We use the terms "expert", "evaluates", and "decision" correctly as the 700si's "fuzzy logic" (artificial intelligence) is capable of recognizing, and reacting to, different photographic situations. These include Close-ups, Portraits, semi-distant or Snapshots and Landscapes. Then it interprets exposure and focus data to get the best exposure for the primary subject, given its analysis of the situation.

Because fuzzy logic is said to emulate the way an experienced photographer evaluates a situation and makes exposure decisions, it is indeed intelligent. It's capable of taking into consideration large amounts of sometimes conflicting information. The evaluation is made instantly, making the entire complex process transparent to the photographer and incredibly fast and efficient.

Expert Program Selection

Control: While pressing the MODE button, turn either control dial until "P" appears on the LCD panel. To adjust apertures in Program mode, turn the rear control dial; to adjust shutter speed, turn the front control dial. The exposure value remains constant; when either value is shifted, the system shifts the other to maintain accurate exposure.

In addition to the above, you can reset the camera to a fully auto-

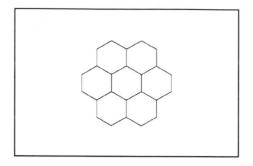

Maxxum 400si Honeycomb Pattern Metering
The 400si's honeycomb pattern metering evaluates 8 picture areas, 7 honeycomb sections and the background, for correct exposure.

matic programmed mode by pressing the button marked **[P]** near the shutter release. Think of this as a "panic button" as it resets the camera to fully programmed. If you are completely lost in a jungle of additional settings and overrides, and have no idea how to find your way home, one touch will restore everything to the default settings in Program mode.

This Expert mode is not only "idiot proof," but also useful to prevent errors in the heat of the moment. To a certain degree, it is the "compact camera" setting which allows even inexperienced photographers to take good pictures in most situations. Combined with multi-zone metering – which is automatically activated – Program will produce acceptable results much of the time.

Now, the 700si does most of the thinking for you: it sets aperture and shutter speed and takes care of all other functions such as film transport (single exposure mode), AF mode, metering, etc. Standard values will be used to produce a good picture based on "Expert" assessment.

In **"P"** mode the 700si uses fuzzy logic to recognize the basic situation as explained earlier. It then optimizes f/stop and shutter speed for the scene. For instance, it selects smaller apertures for closeups to compensate for reduced depth of field while maintaining hand-holdable shutter speed. For a portrait, it selects a moderately wide aperture to blur away the background while assuring sharpness from nose to ears.

Unlike early AE Programs, Expert AE is able to select from a broad range of aperture/shutter speed combinations. If the AF sensor detects that the subject in focus is moving, it will immediately bump up the shutter speed to prevent blurring. There is no need to set the camera to a special "anti-shake" mode or closely monitor the settings it has selected.

Overriding the Expert

Although the settings are made by the 700si in Program mode, you can instantly input overrides. Turn the front control dial for instance, to shift shutter speeds and the 700si switches into the **"PS"** mode - the system will adjust the aperture to maintain correct exposure.

The earliest Program modes were, in comparison, simple and confined to a narrow range of apertures/shutter speeds. By 1994 however, cameras like the 700si have become particularly sophisticated, selecting the most appropriate combination based on numerous criteria. Depth of field and camera shake considerations are significant components in the decision making process.

In spite of the availability of Program shift, the 700si also offers Shutter and Aperture Preferred modes as well as a fully Manual option. This makes it possible to set your own priorities which better reflect your photographic intentions when these frequently differ from camera selected combinations.

Programmed Features At a Glance:
- Exposures are made at the optimum aperture for the situation until the shutter speed approaches shake-critical speeds (e.g below 1/60 sec with a 50mm lens).
- In selecting an aperture/shutter speed combination, the system considers factors such as focal length, subject reflectance and contrast, subject distance and type, as well as the reproduction ratio.
- The fuzzy logic system can recognize various situations and optimize the program to emphasize high shutter speeds (freezing motion) or small apertures (for extensive depth of field).
- Flash is activated when appropriate if the user has pressed the button to raise the built-in head or is using an accessory unit.

- The photographer retains the ability to shift aperture or shutter speed, dial in exposure compensation, set auto bracketing, select a specific focus sensor, etc., for full creative control.
- Pressing the [P] button resets the camera to standard values and fully programmed operation.

The Debate About Programmed Mode

Some photographers scorn even the most intelligent Program mode, deeming this to be abandoning control to a computer. Refusing to switch to a "point and shoot" mode, they insist on remaining in Manual, to control every variable: exposure, depth of field, the rendition of motion, and so on.

Others view Program mode, combined with Expert honeycomb metering, as a valuable amenity for occasional use. They find it frequently useful in subject oriented photography - to guarantee more accurate exposures and suitable depth of field when getting the picture is more important than the process. In complex lighting conditions, for wildlife and photojournalism, for sports and fast breaking action situations, they'll switch to Program, shifting aperture or shutter speed if necessary.

Even the authors of this guide have differing viewpoints on this topic. But this is merely academic because the 700si offers all the requisite overrides - plus Manual mode - allowing the photographer to make all (or some) of the decisions himself. However, when you want to increase the odds of capturing the decisive moment, do not hesitate to switch over to Expert Program Selection. By making the necessary calculations, it will allow you to devote more time to other considerations: composition, watching the play of light and shadow, or capturing a baby's smile at a moment which will not recur.

Autofocus Technology

The fact that the Maxxum/Dynax 700si focuses itself is no longer considered an impressive achievement. But this camera's autofocus (AF) system is unusually successful, superior, in terms of speed and accuracy, even to the previous xi-series cameras which were already highly rated. It was Minolta who introduced the world's first commercially successful autofocus SLR with the original Maxxum/Dynax 7000. That "first generation" AF system worked well in ideal conditions but had many limitations. These have since been overcome with technology light years ahead of that available in 1985.

Omni dimensional predictive AF recognizes changes in the subject's speed and direction, and continues to hold focus over a series of frames. At the heart of the system is a unique module with four high density CCDs containing a total of 836 pixels, assuring quick focus detection and in dimmer light than its predecessors.

The 700si's Expert AF System features an ultra-wide focus frame with the four focus detection sensors and automatic subject detection. This combination makes composing off-center subjects quick and sure, frequently precluding the need to first find focus and then recompose with autofocus locked. More positive AF on low contrast subjects and faster AF mode selection distinguishes the 700si over the previous generation xi models. This chapter will also be helpful to the 400si owner and should be reviewed.

Focus Control

As soon as the 700si is activated, the computer selects one of the four areas for focusing. Press the [AF] button on the back of the camera. A small box will appear on the viewing screen to denote the sensor which has found focus from among several objects in the scene.

If you do not wish to leave the decision to the system, simply press the [AF] button and turn the front control dial to select one of the four sensors defined on the viewing screen. When shooting

tight closeups of people, for instance, select the top focus sensor with the camera in a vertical orientation. This can help assure focus on the face, the important area in terms of sharpness.

But there's another means of assuring pinpoint focus control without switching over to manual focus. Once focus is set on an ideal spot, recompose while maintaining slight pressure on the [AF] button or the shutter release. The latter also locks exposure for the primary subject, which is often desirable.

Omni-Dimensional Autofocus

While all current autofocus SLRs can track subjects moving toward the camera at a constant speed, the 700si is Omni-Dimensional. It can maintain focus on more complex types of motion, even if erratic: objects moving in any direction, making a U-turn, accelerating, decelerating, etc. Improved data computing also enables faster tracking than with any previous Maxxum/Dynax camera.

The term "predictive" AF is common these days with all brands. Far more than advertising jargon, this capability revolutionized action photography with autofocus. Here is a brief explanation: There is always a delay between the moment focus is achieved and the instant of actual exposure; while the aperture stops down, mirror flips up, and the shutter curtain opens. Though measured in milliseconds, this "time lag" is significant in action photography as the subject can quickly move beyond the point of focus.

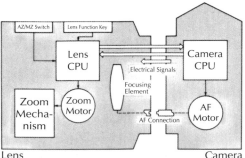

A computerized camera requires substantial amounts of data to flow between camera and lens (and vice versa); this transfer occurs via gold plated electronic contacts.

To produce more accurate results, predictive or "anticipatory" focus was developed. These systems calculate subject velocity and anticipate the point it will reach at the precise instant of exposure. With the 700si, multiple reading are taken during each second for maximum accuracy. Then, focus is set for the predicted position to ensure sharp focus.

For example, the 700si equipped with a 300mm AF lens is said to be capable of maintaining focus on a subject 25 yards away approaching at 155 mph (over 250 km/h). While autofocus is not foolproof in real world situations, the 700si is indeed a highly successful alternative to manual follow-focusing for all but the most experienced action photographer.

Demystifying the Technology

Since the Owner's Manual offers little in the way of explanation as to how the various "Intelligent" systems operate, let's consider some of the other fine points in laymen's terms.

The autofocus mechanism is controlled by a computer: a CPU or Central Processing Unit. Like all data processing systems, it requires certain basic information to make its assessments and translate those into decisions - selecting a suitable point of focus or continuous AF for moving subjects. The 700si's computer evaluates the following information:

* the distance measured by each sensor
* the location of each sensor in the frame
* the lens focal length
* camera position (vertical or horizontal orientation)
* whether subject motion has been detected

Omni-Dimensional Predictive Focus Control constantly recalculates subject distance and speed; subtle adjustments in focus occur right up to the instant of exposure. This even continues while the reflex mirror is raised and the diaphragm stopped down.

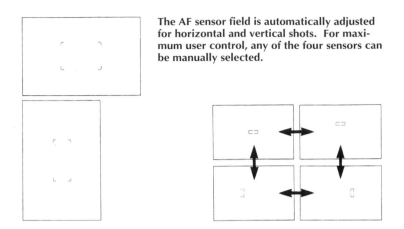

The AF sensor field is automatically adjusted for horizontal and vertical shots. For maximum user control, any of the four sensors can be manually selected.

This data is examined by the camera's "fuzzy logic" processor to determine the probable type of scene encountered. If it's a landscape, for instance, focus is set for a nearby point. If it's judged to be close-up, focus is set on the point covered by the central AF sensor. If motion is detected, continuous tracking AF is activated. This has proven to be successful in numerous common situations with focus set for the most important part of the subject. If a particular sensor cannot find a suitable target, another sensor is selected.

Note: *We use the term "fuzzy logic" frequently in this guide. This is merely a computer control process which is able to deal with situations which do not fall within neatly defined parameters. Unlike standard digital computers, it will evaluate the world more like the human mind: with flexible descriptions of the situation, and responding continuously to any changes it perceives. Decisions are made instantly, while subtle changes are implemented as necessary for smooth stepless control of shutter speed, f/stop, focus, exposure, and other technical factors.*

Autofocus in Low Light Conditions

As mentioned in the Specifications, the AF system will operate in low light down to EV -1. Using a film speed of ISO 100 this trans-

lates to an aperture/shutter speed combination of f/5.6 at 60 seconds or f/1.4 at 4 sec. with a "fast" lens. In other words, the 700si can focus on a subject illuminated by a candle in an otherwise dark room. A certain amount of contrast is also required for the system to succeed, so a plain white wall (for instance) does not make for an ideal target.

The exposure values and aperture/shutter speed combinations above are used only as specific measurements. The bottom line is this: no other current camera can focus in lower light levels than the 700si. For practical purposes you need only remember that the CCD sensors require some light and some contrast, just as your own eyes do.

In difficult conditions, the 700si can actually produce that light/contrast by projecting a near infrared pattern of lines onto the subject. The AF Illuminator (a small red lamp on the front of the camera) can help when photographing in close range up to 23' (0.7m) away. It is activated automatically to help the AF system focus in darkness except with focal lengths beyond 300mm or when the subject is out of range.

"Release Priority" Autofocus Mode

Control: Open the card door and press the ISO and film transport buttons simultaneously. The symbol [AFP] appears in the LCD data panel. Release the buttons and turn either control dial until the symbol [RP] appears.

The camera's standard autofocus mode is Focus Priority shutter release: the 700si only fires when focus has been confirmed. This is logical as it helps ensure a high percentage of sharp photos while shooting moving subjects in continuous film advance mode. Lightly pressing the trigger measures and then stores distance and exposure data. Only then is the picture actually taken, at up to a full 3 frames per second under ideal conditions when autofocus can be consistently maintained.

In some cases the autofocus system cannot hold focus when, for example, the subject drifts beyond the AF sensor area. Then the speed of film advance will reduce as the system continues to seek a target. Switch to Release Priority AF mode, however, and

Absolute sharpness is not always the primary goal in every form of photographic expression.

the shutter will release at the full 3 fps, even if the subject is not sharply focused for every frame. Predictive tracking focus will continue to operate, though at reduced efficiency. Even if not every frame is sharp (because you momentarily lost the target), you should get at least a few dynamic action shots.

If you press the AF/M button for manual focus mode, the shutter will release at any time. You will discover that certain subjects call for manual focus, such as studied landscape work, macro nature photography, and portraits where the exact point of focus is critical. Electronic rangefinder assist is provided; the viewfinder focus confirmation signal confirms when one of the four AF sensors detects sharp focus.

Autofocus Lock

Although the 700si has four focus detection sensors, you may find a tendency to routinely center your subject. Our advice is to divide your preparation for each shot into two distinct steps: achieving focus and selecting composition should be consciously separated. You will otherwise run the risk of only taking pictures

where the subject is dead center, which is less than pleasing in many situations. Proceed as follows:

- Center the subject and lightly depress the trigger. Focus is achieved and maintained while your finger remains on the shutter release button.
- The exposure value is determined at the same time and is locked in as long as you maintain pressure, in honeycomb and spot metering.
- Now select the actual image composition while keeping your finger lightly on the shutter release and then press all the way down to take the picture.

This technique sounds complicated at first, but becomes second nature after a few rolls.

Autofocus Hints

- The AF Lock technique should not be necessary unless the subject is located near the edges of the frame.
- Don't give up if the autofocus system refuses to confirm focus. Selecting another target right beside the first or slightly tilting the camera usually helps.
- If this fails, select another subject at a similar distance. Or, turn the autofocus system off. Manual focus (selected with the [AF/M] button on the left lower body area) remains a useful method when even the most sophisticated automation cannot meet the user's need.
- With most lenses, the front element rotates when focusing. This means that the filter thread will turn. Polarizers and some other filters (graduated, star filters, etc) require a very specific position in order to be effective. Set focus first and then adjust the filter to the correct position to ensure its effectiveness.

With the 700si, autofocus has become exceedingly fast, precise and responsive to a vast range of subjects and circumstances. While we find AF highly successful, it's comforting to know that it remains optional. Even if you frequently choose not to use it, autofocus is another important tool in the photographer's arsenal.

Fully Utilizing the 700si

By this point, you should have learned how to use the basic functions of the 700si by relying on the Owner's Manual, and using our hints. So let's move into the next phase: learning to take advantage of the other features.

A particular advantage of the Minolta 700si is that the settings that are in use when the camera is turned off are recalled when it is turned on again. The combination previously selected is immediately available without the artificial intelligence second-guessing the owner. This is exactly as it should be no matter how closely fuzzy logic can mirror our intentions.

Semi-Automatic Modes

Control: *Press and hold the [mode] button and turn either control dial until |A| or |S| appears in the LCD panel. The first denotes Aperture Preferred and the second Shutter Preferred semi- automatic mode.*

In comparison to the basic Program mode, these offer the following advantage: the photographer concentrates on one essential parameter and lets the camera control the other. In truth, exactly the same can be achieved with Program shift, covered elsewhere. However, because conservative photographers insist on the familiar methods of operation, Minolta wisely incorporated these semi-automatic modes.

In Aperture Preferred mode, the f/stop is selected by turning one of the control dials. You can set any available aperture in 1/2 stop increments while the exposure system sets a corresponding shutter speed. Besides shooting a series at f/27, for example, it's also useful for maintaining the aperture at which the optics pro-

Shutter Preferred mode is often the right choice for action photography; set a high shutter speed in advance and the 700si responds with the corresponding aperture.

vide maximum sharpness. As a rule of thumb, any lens provides optimum image quality two or three stops down from wide open, typically at f/8 to f/11 with zooms.

Exactly the opposite occurs in Shutter Preferred mode. You select a shutter speed (in half steps) with the control dial and the camera responds instantly with the corresponding aperture. This is most useful when shooting motion, assuring that the subject is either frozen or depicted as flowing. It's also valuable when shooting with telephotos, to avoid the risk of a low shutter speed which would create blurring from camera or subject movement.

When you think about it, you'll recognize that it is also possible to influence the shutter speed with the selection of an f/stop. A wide-open aperture (such as f/4) will always result in a faster shutter speed than a small aperture (such as f/16). If you are using [A] mode, a quick glance into the viewfinder keeps you apprised of both factors.

As a practical example, let's say you're shooting with an 80-200mm f/2.8 APO G on a sunny day. Set f/2.8 in Aperture Preferred mode and the system will provide the highest possible shutter speeds given the lighting and film speed in use. This should ensure that the shutter speed will not be too long for hand-holding the lens.

The same is true, with the opposite assumption, for Shutter Preferred mode. Although the primary emphasis is on selecting an exposure time, the aperture is directly influenced by the choice of speed. Depth of field control remains possible; high shutter speeds lead to wider apertures, minimizing the range of sharp focus, for instance.

Metering Hints

These semi-automatic modes can be useful in combination with spot metering. Contrast can be measured by taking a reading of the brightest and darkest areas of the scene in terms of shutter speed or aperture increments. By measuring the contrast range in Aperture Preferred mode, for example, the difference between the brightest and darkest metering point can be read directly in stops. (The Metering Index scale is useful, too, but offers only a +3 EV to -3 EV range).

You can then calculate whether the contrast range of the subject's brightest and darkest points exceeds the recording range of your film - a maximum of 5 stops for slides and 7 for print films. In this manner you can determine if all the important details will be reproduced in the photograph.

At a Glance:

* Specific values can be set in Aperture or Shutter Preferred modes to satisfy photographic intentions.
* Exactly the same can be achieved with Program shift — with temporary access into either semi-automatic mode.
* In Aperture Preferred, the photographer determines the aperture and hence the extent of depth of field.
* In Shutter Preferred, the photographer controls the depiction of motion, from frozen to blurred, by selecting the appropriate shutter speed.
* If the f/stop or shutter speed symbol blinks in the viewfinder, subject brightness is either excessive or too dark for the combination selected; exposure error will occur unless you select another f/stop or shutter speed.

Storing Customized Settings

Control: *Set a combination of frequently used camera settings (metering pattern, aperture or shutter speed, film advance, AE mode, compensation values, specific AF sensor, etc). Now press the tiny (unlock) button to the left of the prism and slide the lever to ENTER at the same time.*

The 700si's Memory function offers the photographer the option of saving all important camera settings so that they can be recalled at the simple touch of a button. Any combination can be memorized for instant recall later by pressing the [M] button. Your customized program is maintained even if the camera is switched off or the battery is removed. New programming overrides the old settings, useful when you switch from shooting nature closeups to a motorcycle race, for instance.

Everyone can thus build his own program, modifying it as desired at any time by using the Control procedure described earlier. A

touch of a button suffices to recall all these settings. Naturally, after recall, you can still shift or adjust any of the camera functions.

The following is a sample of the combination we might program for instant recall at a speedboat racing event:
- Shutter Preferred mode set to 1/1000 sec. as a starting point
- Continuous film advance for shooting a series of exposures
- +1/2 stop of exposure compensation; metering mode set to Expert honeycomb pattern
- Wide area AF for more effectively tracking erratic motion without losing the target
- Release Priority AF to allow shutter release (during a sequence in Continuous film advance) even if not every frame has focus confirmed

This is only a single example. Many more could be given that would clearly demonstrate the value of programming the 700si for specific subject matter - insects, environmental portraits, architecture, landscapes and so on. While the Expert Program Selection feature is fine for quick shooting, we feel that most advanced photographers will appreciate the ability to create their very own programs with the uncomplicated approach described earlier.

Some readers will suggest that they would like several of these stored combinations available for instant recall; one for sports and another for closeups of the athletes, for instance. In our opinion, however, Minolta did well to limit the 700si to a single stored program. If there were more storage options available, the risk of confusion would set in. Which series of functions is stored

Memory Recall Button

in which location? And which location do I need to recall to activate which combination of functions? As you can see, the camera would start to become unmanageable.

Besides, let's not undermine the usefulness of Expert Program Selection. While this allows the computer to make all the decisions, it does incorporate artificial intelligence. You may well find that the system selects nearly the same combination of settings that you would program, given the availability of several memory channels within the 700si.

Program Shift Controls

Control: *Use the front control dial to change shutter speed and the rear dial to change aperture in Program (and all other modes).*

The Maxxum/Dynax 7xi was the first Minolta SLR to include two control dials for uncomplicated camera operation. The concept has been refined for the 700si. Both have been repositioned for more comfortable operation. And the click detents have been strengthened for greater tactile feedback.

As mentioned elsewhere, the dials are used for changing all camera functions, in conjunction with a button in some cases. Most importantly, these allow a shift in either shutter speed or f/stop at any time in Manual, Program, or the semi-Automatic modes. When Program is active, the dials provide immediate temporary access to the semi-Automatic modes for quick adjustment of shutter speed or aperture based on your own decisions.

When shifting aperture or shutter speed, the LCD panel displays **"PA"** or **"PS"** respectively. To revert to the standard program, press the **[MODE]** button. **The latter may be necessary because flash will not fire in these sub-programs.**

Important Note: *Except in Manual mode, the overall exposure does not change when you change the aperture or shutter speed! Remember, many combinations of aperture/shutter speed allow exactly the same amount of light to expose the film. In semi-Automatic and Program modes, equivalent combinations are selected. Depth of field and the depiction of motion will vary from one to another, but exposure will remain constant.*

Experiment with the shift and watch the indicators in the view-finder. You will see that both values change simultaneously. If the aperture is being closed down (e.g. from f/5.6 to f/8), the shutter speed will change proportionately (e.g from 1/250 sec. to 1/125 sec.) to maintain an equivalent exposure.

The film does not care whether it is exposed for 1/500 sec. at f/2.8 or 1/15 sec. at f/16. In both cases, the same amount of light reaches the film since the aperture was closed by five stops but the exposure time lengthened by an equal five steps. The technical term for this effect is "reciprocity". Except at long shutter speeds (several seconds or longer) the film will be correctly exposed. "Reciprocity failure" occurs at long exposures due to a loss of effective film speed. Check the notes included with film if planning to shoot timed exposures.

Nonetheless, the photographer cannot be indifferent, since the depth of field varies substantially from f/2.8 (shallow) to f/16 (extensive). And the depiction of motion varies depending on the exposure time: frozen at 1/500 sec. and blurred at 1/15 sec. in this example. Long exposure times can also lead to camera shake unless you are using a tripod.

At a Glance:

- A shift in f/stop or shutter speed in semi-Automatic or Program modes does not change the exposure value.
- Shutter speed and aperture can be selected in half stops; the system then sets the other variable in a stepless manner (e.g. f/9.766 or 1/299 sec.) for fine exposure control. The display shows the nearest 1/2 stop reading.

Exposure Metering Basics

Until now, we have not explored the various exposure control options in any detail, relying on the Expert honeycomb pattern system. Before we delve into this new topic, let's begin with a review of the basic concepts of exposure metering. We'll concentrate primarily on Spot and Center Weighted metering instead of the Expert evaluative system because computer-controlled metering inputs its own compensation, as explained later.

When you switch to the conventional Spot or Center Weighted

pattern for full control, remember this: The meter is calibrated to medium grey which is equivalent to an 18% reflection. This value was arrived at with the assumption that most pictures have a contrast range of 1:32. And this is true of common outdoor scenes containing grass, dirt, rocks, trees and sky, for instance. The various reflectance values average out to a median value with a density of 0.75 or 18% reflection.

Concentrate the meter reading on any point and the exposure meter will render it as a mid-tone (in the middle of the exposure range of the film). Take a reading from a white snow drift, or a black Rolls Royce, or a gray tree trunk and it will be reproduced as medium gray. If this will not achieve the desired effect, you'll need to use other methods described later.

The meter built into the 700si (and all other SLRs) measures light reflected back from the subject through the lens. Hence the term Through The Lens (TTL) metering. It is obvious that a white surface reflects more light than a gray surface - roughly 2 stops more. And a black surface reflects less light - roughly two stops less.

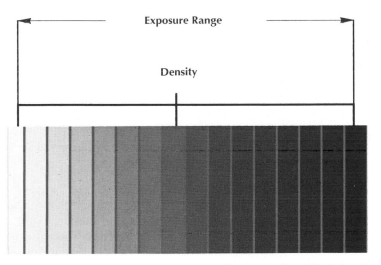

This step wedge illustrates the progression from white to black in steps of increasing density. The difference in density between each step is equivalent to 1/3 f/stop.

This high-key portrait was perfectly exposed by the 700si's sophisticated honeycomb pattern metering system. No additional exposure compensation was required.

Compensating for Exposure Accuracy

Take a picture of a black cat in a coal bin and the meter will assume you are shooting in low light. It will overexpose the scene to the standard mid tone density, rendering it as grey if faithfully printed by the lab. For a natural rendition shoot at 2 stops less (-2) than the meter recommended value to get black instead of gray.

Shoot a swan against a white wall and the system will assume it is faced with an overly bright scene. It will underexpose the situation unless you add (+) 1.5 to 2 extra stops of exposure to keep it white.

Substitute Metering

Another alternative is "substitute metering". In honeycomb pattern or Spot metering, take a reading from a mid tone in similar light. Grass, foliage, worn pavement, a gray *Domke* bag, tanned skin, a Kodak gray card, etc. make for suitable substitutes. With the 700si, hold the metered value while recomposing, with slight

pressure on the shutter release button. Now the mid tone will be rendered as a mid tone, whites as white and dark tones as dark.

Metering Hints:
- The above assumes you can identify a mid tone; fortunately nature provides many, but you can buy a gray card to be certain.
- In Center Weighted metering, pressure on the shutter release button **does not lock the exposure -** it only locks autofocus.
- In Spot metering, maintain pressure on the [SPOT] button to lock in exposure in AE modes.
- The 700si does not include an Auto Exposure Lock with Center Weighted metering. Dialing in exposure compensation or switching to metered manual mode is required if you want exposure control with this pattern.
- Substitute metering should not be required with the Expert honeycomb metering system **when using print film**. The fuzzy logic processor evaluates the scene and automatically inputs some compensation. This may not be adequate with black subjects or a snow covered scene, but the film's broad latitude allows for good prints to be made.
- Because the Expert honeycomb may not adequately correct for a black or white subject, we find substitute metering useful in such situations **when shooting slide film.** A reading taken from a neutral tone produces more accurate exposure in a snow covered scene, for example.
- To compare the amount of compensation the Expert meter has applied in any situation, use the Exposure scale in the viewfinder. This will display the difference between its strategy and a straight Center Weighted reading. With experience, you can determine whether this is adequate for an ultra bright winter scene, for example. (If three pointers appear, ignore all but the central pointer).

No computerized system is foolproof, nor can it read your mind to determine the effect you intended. For critical exposure control, Spot metering, with a knowledgeable decision as to the spot to be rendered as a mid tone, is still the most exact method. Meter a tanned face exclusively, for instance, and the overall results will be accurate and pleasing.

Exposure Compensation

Control: *Press the [+/-] button to left of the lens mount and simultaneously turn either control dial until the compensation factor you want appears on the LCD panel (in +/- 0.5 stop increments to 3 EV in each direction).*

With the help of compensation, the exposure can be exactly biased in 1/2 EV increments between -3 and +3 EV. (An EV is merely an aperture stop or shutter speed step or a combination of both). Remember the black cat in the coal bin? To render it black with spot or Center weighted metering, dial in -2. For the all-white scene, dial in +2 to get a bright rendition as intended. (This is simply a rule of thumb; the 2 stops mentioned are not exact).

The Exposure scale in the viewfinder can be accessed by pressing the [+/-] button. Now you can confirm the correction you have made with a pointer denoting -2 and +2 respectively in the examples above. If the correction is to the minus side, the film will get less light - under-exposure as required to avoid rendering black as gray. Conversely a plus correction results in an over-exposure - useful in rendering white as clean and bright.

This option can be used to achieve special high or low key effects as well; for example, intentionally overexposing the bride in white surroundings or underexposing the groom against a black background for effect. And if you want to take advantage of the double exposure feature of the 700si, a correction value between -0.5 and -1.0 will usually be needed.

A Note of Caution:
Expert honeycomb metering will frequently input some compensation automatically or alter its pattern to ignore a bright sky, for instance. Except with black or white subjects, this should prove to be adequate. We do not recommend trying to second guess the system. For the most predictable results, switch to Spot or Center Weighted metering if you intend to use the Exposure Compensation function.

It makes little sense to take the trouble for this procedure to correct exposure for a single image. The process is unnecessarily

time consuming. Besides, the danger exists that you'll forget to deactivate the compensation, causing subsequent pictures of average scenes to be incorrectly exposed. While the lab can correct for this to some extent with print film, slides may be unusable.

If one or a few images require override, the substitute metering strategy mentioned earlier makes more sense. If you suspect that an ultra bright sky will cause underexposure of the entire scene, merely point the camera down to read only the grass and tree trunks. Lock a honeycomb meter reading by maintaining pressure on the shutter release button and recompose. Or, take a Spot reading of a mid tone (grass is suitable) and recompose with the exposure reading locked in with pressure on the [SPOT] button. Full manual control of both aperture and shutter speed (described later) is another valid option.

Automatic Exposure Bracketing

Control: *Press and hold the [+/-] button left of the lens mount and simultaneously depress the trigger. Three images will be taken while the trigger remains depressed; the first 1/2 stop under metered value, the second at normal exposure and the third 1/2 stop over. The 700si will stop firing after three frames have been exposed.*

Routine bracketing (varying exposure from one frame to the next) is not a recommended alternative to developing metering skills for advanced photography. But even the most conservative professionals will bracket a difficult situation as insurance. With the 700si you are limited to half stop increments and three frames with automatic bracketing, but this is generally adequate with skillful judgement or Expert honeycomb metering. One shot will be under-exposed by half a stop, the second exposed at the "correct" value and the third over-exposed by half a stop.

This function is particularly useful with slide film whose exposure range is very narrow. Even a difference of half a stop can change a shot from acceptable to perfectly exposed. In some cases you will get three useable slides, but the mood or effect will vary from one to another.

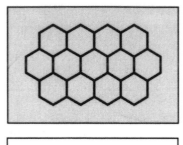

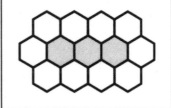

The 700si's silicon photo diode cell is divided into 13 honeycomb-shaped segments plus a background zone. Depending on which type of exposure metering is active, certain segments are weighted or used exclusively.

In Expert honeycomb metering, the 700si decides (using fuzzy logic) which segments will be weighted for the final exposure. In Center Weighted Average metering, the central elements are heavily weighted. Only the single, central segment is used for spot metering.

If a negative film is loaded, these 1/2 stop increments will not be adequate. A full 1 to 1.5 stops are required for a noticeable difference when making prints. No such adjustment is possible with the 700si itself, so you'll need an optional Exposure Bracketing Card 2 for greater flexibility (described later). Or switch to Manual mode and vary the aperture or shutter speed using the Metering Index scale as a guide.

Center-Weighted Average Metering

Control: *open the card door; press and release the middle button. Turn either control dial until a rectangular symbol with a circle*

appears in the LCD panel. Lightly press the trigger to enter your selection.

The first "Practice" chapter already dealt with the advantages of multi-zone Expert metering. Its major disadvantage was also mentioned: the photographer cannot specifically determine the exact metering strategy employed by the Expert system. The Metering Index scale offers some feedback, but only as to the amount of exposure compensation input by the system. You cannot, however, determine which segment of the scene was weighted in the metering decision.

The metering characteristics of Center Weighted (and Spot) metering, on the other hand, do allow the photographer the opportunity to interpret the results. This makes them particularly useful with slide film which requires precise exposure corrections due to its limited exposure latitude. When using color print film, however, we recommend Expert honeycomb metering for all but the most dedicated. The system will just about guarantee perfectly printable negatives unless your subject is primarily white or black.

You can determine the different metering characteristics for yourself by mounting the 700si on a tripod and switching between the various patterns. The displayed values will differ more or less depending on the contrast of the selected subject. Information on how honeycomb and Center Weighted metering differ can be obtained by pressing the [+/-] button. The exposure indicator scale will appear on the viewing screen displaying the variation.

In Center Weighted Average metering, the overall subject illumination is measured and added to a central value. In order to accurately expose for the (probable) main subject, the central area carries more weight in the final result than the border areas. The result is a reading emphasizing exposure for the central area of the frame, minimizing the risk of underexposure caused by a bright sky.

This method works very well with average subjects which are not primarily bright or dark, like the summer landscape example provided earlier in this Chapter. This metering pattern is included because experienced photographers, who honed their skills in this manner, demand it. They know exactly when to overexpose,

This graphic depiction of spot metering illustrates the narrow coverage of this form of light measurement.

and to what extent, from a Center Weighted reading in snow, for instance.

If you refuse to put your faith in artificial intelligence, and want a time-tested, understandable method, this will suffice. And a final advantage, many of the books on exposure control assume you are using this pattern because not all cameras incorporate Spot or evaluative metering. They provide detailed lessons as to how to get the best (and most predictable) results in Center Weighted metering with manual control of aperture and shutter speed.

At a Glance:

- Center Weighted metering is a reliable method in even lighting conditions with subjects primarily consisting of mid tones.
- Without exposure compensation (or substitute metering using Manual mode) inaccurate results are produced when a scene's overall value does not average out to 18% reflectance.
- The 700si does not allow for AE Lock with this pattern; to hold an exposure reading in Center Weighted metering when recomposing, switch to Manual mode.

Spot Metering

Control: *To activate it temporarily, press and hold the [SPOT] button.*

Permanent activation: *For full time spot metering, open the card door; press and release the metering mode button. Turn either control dial until a rectangle with central dot appears on the LCD panel. Press the shutter release to enter your selection.*

In order to take a specific reading of a certain segment of a scene (a tanned face, for instance), press the [SPOT] button. The zone which will be metered is delineated in the viewfinder by a pair of brackets etched on the screen. Taking a reading of a narrow 2.7% of the image area means that the selection of the section to be metered is critical to the overall exposure.

Using this method, you can choose a specific area which is to be rendered as a mid-tone in the final image. Spot metering is the right choice if the exposure should depend on a specific subject detail. This strategy will produce the desired exposure **only if the spot is chosen correctly**. To do so, take a reading from a mid-tone or from an object which should be rendered as a mid tone in the final image. A subject's face, a spot lit performer on a stage, or an area of average reflectance is a suitable starting point.

If, however, the metering is consciously done on a spot that is not of medium density, but on bright or dark areas, low and high key effects (respectively) are readily achieved. In other words, the overall scene exposure will be darker or lighter than "average" which is useful for creative work by advanced photographers.

Besides using spot metering to pick out mid tone areas, the narrow metering angle lends itself to comparing the reflectance of several individual important areas of the scene. Press the **[SPOT]** and **[+/-]** buttons so the Exposure Indicator scale appears, clearly denoting the difference between any given spot and all others subsequently metered. In this manner, you can determine the contrast range of the scene to guide your final exposure decisions.

Spot Metering Hints

Restrict your exposure reading to a blossom lit by a single shaft of light, an intimate section of a panoramic landscape in contrasty light, or a backlit eagle on a limb. Instead of averaging the light values of the entire scene, perhaps to the detriment of your intended subject, the 700si's spot meter ignores all but an acute area. Ultra bright or dark surroundings cannot influence the exposure.

Bracketing with the built-in spot meter is also a useful strategy. Let's say you are confronted with a spectacular beach scene including both shadow and highlight areas. Since the broad range of brightness values may exceed the recording ability of slide

film, make a series of exposures by taking successive spot readings, each from a different fragment of the scene.

For the first frame, meter a light-toned sand crab in light shade; for the second, a billowing sail offshore; for the third, a rock in deep shadow, and so on. When the slides are processed, several will be useable but the mood or effect will vary. At least one will most effectively reflect your own creative intention.

We commend Minolta for incorporating a Spot meter in the 700si - for precise exposure control by advanced photographers. In the final analysis, however, the choice of spot or Expert honeycomb metering will be decided based on your level of experience. If you frequently shoot unforgiving slide film, or want to develop precise metering skills with print film, we recommend one of the many books on the market dealing with this topic.

Multi-Spot Metering Options

The 700si will read only a single spot, unlike accessory light meters. The latter can read several, and cumulatively average the

When shooting in the studio where the exposure does not change, or when using studio flash units, full manual control is generally the most appropriate.

readings of two or more points of interest. To add this capability, purchase the optional Multi-Spot Memory Card.

This will allow the camera to store up to eight spot exposure readings, allowing the experienced photographer to solve complex lighting situations. Use this to fine tune the results by weighting the exposure toward a desired area, taking two readings from a rock climber plus one from the bright background, for example. The result should be a well balanced image with the main subject nicely exposed and the sky area acceptable as well.

Manual Exposure Control

Control: *Press and hold the [MODE] button; turn either control dial until [M] appears in the LCD panel. The metering index also appears in the viewfinder.*

Having switched the 700si into fully Manual mode you are now in total control of all the variables. The "safety net" of automation has been removed and you are left to your own devices - with only general exposure guidance provided by the Metering Index scale.

This mode is intended to be a "matching" exposure method with the 700si. Select any of the three metering patterns - Expert honeycomb, Average or Spot. Now the Index will show you how the aperture/shutter speed combination you have selected compares with the meter's suggested exposure.

The pointer's position along the scale denotes whether your selected settings will produce overexposure (+ numbers) or underexposure (- numbers) and by how many stops. Shift the aperture or shutter speed until the pointer hits zero. Now you have matched the meter selected exposure value.

When you decide that this is not appropriate, adjust the f/stop or shutter speed until the pointer denotes the desired value - perhaps +2 for a snow covered scene in sunlight, using Center Weighted metering. The aperture is controlled using the rear control dial and the shutter speed by the front control dial. The selected f/stop and shutter speed are displayed in the panel below the screen; "500 [-] 4" for example, means 1/500 sec. at f/4, which will produce some underexposure as compared to the metered value. The pointer on the scale denotes the amount of exposure deviation specifically.

Working in manual mode is relatively slow compared to auto modes, making it appropriate for studio work or landscapes with a tripod. But it does provide absolute control, which is handy if you want to over- or under expose certain difficult subjects using your own judgement. And in Center Weighted metering this is the only mode which will hold your meter reading even after you have recomposed, as in the examples mentioned earlier.

Note: When shooting long exposures using a tripod, bear in mind that the metering cell of the 700si is sensitive to light entering through the viewfinder. This can produce errors in metering so use the eye piece cover. The cap slips into place to prevent stray light from entering and influencing the exposure.

Double Exposures

Control: Press and release the top button behind the card door; turn either control dial until two overlapping rectangles appear in the monitor. Enter your selection by lightly touching the trigger.

The film transport mechanism is turned off during double exposure, allowing two pictures to be taken on the same frame. In order to ensure that the picture is not over exposed, a certain exposure correction is required. A rule of thumb: dial in -1, or underexpose by a stop in Manual mode, using the Index scale as a guide. The appropriate correction depends on the subject: brightness, overlap, background, etc. Hence, bracketing at -1/2 and -1 stop (in Manual mode or with exposure compensation), is recommended with color slide film.

The best subjects are bright objects in front of a dark background. Double exposures work like sandwiching two slides: an additional subject (perhaps a moon) can be exposed into the dark portion (sky, perhaps). The brighter this area, the less of an effect will result. After the double exposure has been taken, the camera automatically turns the function off.

Long Timed Exposures

Control: *Select manual exposure mode and turn the* front control dial until "bulb" appears in the monitor. Turn the rear dial to set the desired aperture.

The "bulb" setting is available in addition to the exposure time range of 1/8000s to 30s. The shutter remains open as long as the trigger remains depressed. Use a tripod and a Remote Release cable to assure vibration-free results.

At a Glance:
- Reciprocity failure should be taken into account. The effective film speed reduces during long exposures. Check for specifics on the sheet enclosed with the film.
- The shutter remains open as long as you maintain pressure on the button or lock in the trigger of the Remote Release cable.
- The 700si provides no metering guidance in "bulb"; experiment, use an accessory light meter, or follow the guidelines suggested in books or photo magazine articles covering long, timed exposures.

Creative Expansion Cards

"Creative Expansion Cards interface with the 700si just like a software program works in a computer." This is a quotation out of some Minolta literature which explains the use of these cards in providing the 700si with additional functions.

Minolta is unique in offering software cards. Other manufacturers incorporate Custom Functions into the camera or offer multi-function backs for expanding capabilities. While the Cards do require an additional purchase, they are cheaper than a multi-function back. After using your 700si long enough to make an informed judgement, simply buy those you will actually require

Then, insert one of these postage stamp sized software chips in the slot inside the card door to create a variety of effects with ease. The flow of data between the camera's micro computer and the card begins as soon as it is activated. Different camera functions are controlled by the card, depending on the program

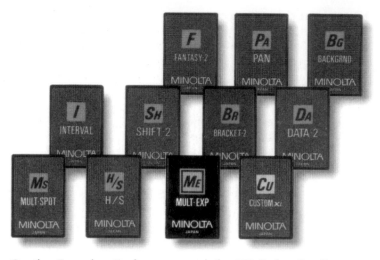

Creative Expansion Cards can expand the 700si's functionality even further.

loaded on it. To deactivate the card simply press the [card] button beside the LCD panel to return to normal camera functions.

A button marked [card AD] is hidden behind the door for use with some cards that expand the functionality of the camera. You must press it in order to set the additional function.

You can determine which card is currently in the camera through the card window on the door of the 700si. You cannot insert two cards simultaneously into this or any other Dynax/Maxxum model. Let's review the Creative Expansion Card System and how it can increase the value of your camera.

Customized Function Card xi

Probably the most versatile card available, this one allows you to customize the 700si to your specifications, as follows.

- Reprogram the function of the [P] button. Normally, pressing this resets the 700si to full Program mode and other default settings. The Custom xi card makes it possible to change all of the settings which will be recalled. You can choose between Program, Aperture Preferred and Shutter Preferred; exposure compensation, honeycomb, center weighted average and spot metering, single AF sensor, etc.

- When using xi-series zooms, the zoom function button can be reprogrammed; the same is true for the focus limit button on some AF lenses. Pressing the latter can be made to provide stop focus, central AF field, and continuous autofocus.

More importantly the Custom xi card allows the following parameters of the 700si to be selected:

- additive or subtractive exposure counter
- manual or automatic film rewind cue
- film leader left out after rewind
- cancel DX film speed setting
- cancel automatic flash activation in program mode
- switch grip sensor "off"

These changes can be made fairly easily through a numeric menu system on the LCD panel. Your choices are stored permanently in the 700si (until you re-insert the card later and make any desired changes). You can therefore take the card out after you have completed customizing the camera.

Hint: If you own an xi Card, you can reprogram the 700si to two completely different sets of tasks instantly. Use the Card for settings suitable in studio work and the camera's own Memory feature for action photography, for example.

Fantasy Card 2

You are probably familiar with pictures where the focal length of a zoom lens is changed during a relatively long exposure. This card automates this function to achieve soft-focus effects.

This card offers two different functions to perform this task. In one case, the focus setting is automatically changed during the exposure, while in the other, a sharp image is overlaid on an unsharp image in a double exposure.

Panning Card

This card is designed to help with panning effects. A slow shutter speed is automatically selected so the background appears blurred while you follow a moving subject.

Background Priority Card

This card lets you select the depth of field you want. The Program then automatically maintains the chosen background sharpness.

I 1, 2 – page 109
Today's high speed films such as Kodak's Elite 400 are remarkably fast with excellent sharpness and grain structure. The top example still shows outstanding results even though the film was "pushed" to ISO 800.

J 1, 2 – K 1,2 – page110-111

A water carnival provided many interesting opportunities for pictures filled with action and the feeling that "something is happening here." The 700si's built-in motor drive was a real asset in capturing the events.

L – M – page 112-113
Flash vs. ambient light:
The example on the right was shot with flash and a slow, fine-grained film. High speed film with existing light was used for the photo on the left. Which do you prefer?

1 | 2

K 1

K 2

SW 8371

SW 2906 ANTON

MISTRAL III

N – O – page 114-115
Successful photography involves recognizing potential subjects with interesting lighting and capturing them with the equipment that is available. Here, the warm, soft colors enhance the mood of these existing light portraits.

P – page 116
Macro zoom lenses are an excellent choice for close-up work when critical, flat-field reproduction is not a requirement. As illustrated here, they work very well for "in the field" nature photography.

When activated, the 700si automatically switches into Program mode and turns predictive tracking autofocus off. Then, it maintains a pre-set range of apparent sharpness. This will be maintained on subsequent shots by automatic adjustment of the aperture. Such adjustment will indeed be required when the focal length or camera-to-subject distance subsequently changes.

Intervalometer Card

With this card in place, the 700si will trigger itself after a specified time interval, shooting a specified series of frames. This interval can be pre-set anywhere from 1 second to 24 hours.

Now, time-lapse photography occurs while the photographer is away from the camera, commencing after the defined interval. This is useful for recording the opening of a blossom or a chick hatching, for example.

Automatic Program Shift Card 2

This card allows a series of three exposures to be fired at different shutter/speed aperture combinations. The overall exposure remains constant while depth of field and the extent of motion blur are varied. The degree of difference can be selected from one, two or three stops.

Exposure Bracketing Card 2

The 700si already has an automatic bracketing function built in. At the touch of a button, the camera takes three shots with a half stop difference in exposure from frame to frame. This card offers many more bracketing options.

Under ambient light, the increments can be adjusted to 0.3, 0.5 or 1 EV; the latter is useful with print film. If manual exposure mode is active, you can decide if the shutter speed or the aperture should be changed automatically. With flash exposures, bracketing in steps of 0.5 or 1 EV are possible.

This card works with all the 700si's exposure modes and sets exposure bracketing for 3, 5 or 7 shots with ambient light or with flash.

Data Memory Card 2

Those who want information as to how the picture was taken after it is processed should consider buying a Data Card. It stores

Certain photographic situations can be mastered more easily with the help of Creative Expansion Cards. With this subject, consisting primarily of highlights and shadows, the H/S card would be a suitable choice for a high key effect.

technical information on up to four rolls of 36 exposure films in memory. The following data is stored: exposure mode, shutter speed, f/stop, focal length, lens speed, exposure compensation and film speed.

This information can be recalled at any time on the LCD panel and can be cancelled. As soon as the storage capacity is reached, a warning symbol appears and data about the first roll (previously stored) is over-written.

Multi-Spot Memory Card

This card stores up to 8 individual spot meter readings and cumulatively averages these together for the final exposure which will be used when the camera is triggered. The computed value remains stored for all subsequent exposures until the card is deactivated. This card works with all 700si manual and automated modes.

Highlight/Shadow Control Card

This card automatically provides exposure compensation for

either black subjects or white subjects, for a more accurate rendition. Depending on which function you select on the card, you can perform spot metering to favor the highlights or the shadows.

Meter a highlight area, the brightest part of the subject which should still show detail. This metered exposure will then actually be shot with a compensation of +2.3 EV keeping snow pure white, for instance.

The same is true with the opposite approach for shadow metering. Take a spot reading from the darkest area which should still show detail. The card adjusts exposure by compensating at -2.7 EV, rendering it a deep black instead of gray.

Multiple Exposure Card
Up to nine pictures can be exposed on a single frame of film with this card. Since the exposures are not compensated, this card will not automatically produce accurate exposure; user input is required. For satisfactory results, dial in the appropriate compensation. You'll find hints in the instruction sheet to avoid rendering the subject as excessively bright.

This card offers a unique feature with its fade in and fade out effect. Here, the intensity of subsequent images can be increased or decreased.

In fade-in mode, the subsequent shots are taken with longer exposures until the last shot is taken with the metered exposure. The subject seems to emerge from the darkness.

Exactly the opposite is true with the fade-out mode. Here, the first shot is taken with the full exposure and the subsequent ones with shorter exposures. The subject seems to disappear into the dark background.

Naturally, some of these Expansion Cards will seem redundant, while you'll want a couple of others right away. Your decision will depend on several factors: whether you shoot print or slide film, your choice of subject matter, a desire to automate certain manual functions, and the willingness to program the 700si with software like a computer.

The 700si is well-suited for most shooting situations. For unusual ⇨ requirements or for special effects such as this, Minolta Creative Expansion Cards further extend the capabilities of the camera.

Better Flash Photography

The Maxxum/Dynax 700si is one of the most versatile cameras on the market when it comes to flash photography. In this chapter, we'll review the various features and optional accessories which can produce advanced effects with artificial illumination. Many of the features and principles discussed here also apply to the 400si camera.

Like many current SLRs, the 700si has a small built-in flash head which can be raised and lowered by hand when desired. On some previous models, the head automatically popped up but we found this annoying. Battery drain was another factor. This built-in flash has a guide number of 39.6' (12 meters) with ISO 100 film. That's not particularly high but is quite adequate indoors with nearby subjects or with ISO 400 film. It also works well outdoors to fill in shadows covering a subject's face, for example.

The small flash head built into the 700si is always available.

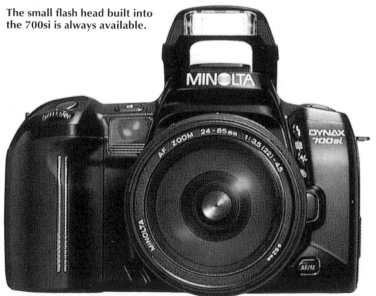

Many of its functions are identical to those of the larger accessory units. Where the latter differ we'll make perfectly clear to prevent confusion.

Basic Flash Operation

The 700si automatically provides proper exposure for fill flash and for full illumination indoors for subjects within its range. Red-eye reduction mode can be set, activating a series of pre-flashes to minimize this syndrome in dark conditions.

The 700si is designed to recognize basic lighting conditions and adjust its settings to achieve the best results automatically. The system determines whether flash should be used as fill or as the main light based on its honeycomb metering. A comparison between the subject and background is made to determine the level of intensity which would be most appropriate. This will be minimal in daylight and higher in darkness. The background will be nicely illuminated by an appropriate shutter speed/aperture combination to maintain sufficient detail. With the built-in head, shutter speeds in the 1/60 to 1/200 sec. range can be selected.

The camera's TTL (through the lens) metering system monitors the amount of light which reaches the film and automatically stops flash output when sufficient exposure has been received. In backlight conditions, the ambient light exposure of the subject is reduced by one stop. The flash brightness is reduced as well to maintain proper subject exposure and to prevent overwhelming the natural light. In the final picture, the background will be up to 1.5 stops darker than the subject, a pleasing effect overall.

Note: *The flash will not fire in Program mode if the aperture or shutter speed has been shifted (into "PA" or "PS" mode). Press the [MODE] button to return to the standard Program.*

Red-Eye Reduction

Control: *Press and release the flash mode button behind the card door. Turn either control dial until an eye appears in the LCD panel. Enter your selection by lightly pressing the shutter release button.*

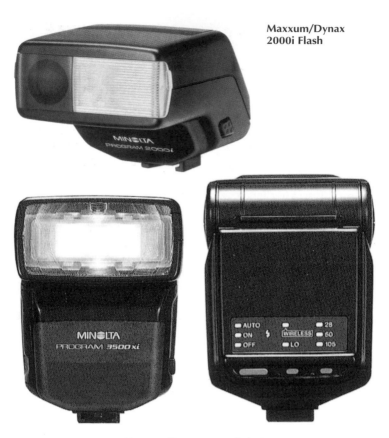

Maxxum/Dynax 2000i Flash

Maxxum/Dynax 3500xi Flash

Red eye is caused by bright light reflecting from the blood vessels in the retina of the eye. This is especially problematic in dark conditions because the pupil is wide open exposing the full surface of the retina. When pre-flash is activated, a series of four small bursts are fired before the main burst during the exposure. This number is generally adequate to minimize red eye without wasting battery power. The purpose is to force the subject's pupils to contract, thus reducing the size of the exposed area of the retina. In truth, the red eyes are actually smaller, since the pupils do not fully contract.

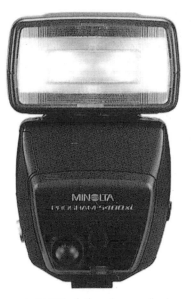

Maxxum Dynax 5400xi Flash

A 100% fail safe pre-flash mode (to totally prevent red-eye) does not exist. Only a reduction can be achieved, but this is all that's required for a 4x6 print or any size print where the eyes are not overly large. The risk of red eye is greatest when the flash is close to the lens axis as with any built-in flash unit. Hence the need for pre-flash mode to minimize the effect with on-camera flash. If red-eye is still noticeable, try *Spotone 3* retouching liquid, carefully applied (in minute amounts) with a 000 sable brush. Both are available wherever darkroom supplies are sold.

System Flash Units

If you are using a compatible Maxxum/Dynax TTL flash unit, certain camera functions are set automatically, as with the built-in head. Exposure metering is done through the lens (TTL): an independent metering cell in the 700si measures the light reflected from the film, controlling the flash duration. Film speed and any exposure correction are taken into consideration.

Program mode is all that is required for much day-to-day photography. Aperture or shutter speed can be specified in other

modes (as we'll see later in this Chapter) for more creative work. The basic operation in Program has already been described; it is identical with the built-in or an accessory flash unit. *Differences do exist with the 5400HS flash, but these will be specifically reviewed later.*

When the flash unit is ready to fire, the 700si sets the following functions:

- The Program chooses a sync speed between 1/200 sec. and 1/60 sec.; the aperture is selected depending on the distance.
- film sensitivity and exposure corrections are taken into account.
- the flash symbol in the view finder indicates ready state.
- automatic fill flash is activated in backlight conditions.
- With accessory flash guns, exposure error can result if the flash unit was not recycled when the shutter release occurs.
- If the accessory flash has a zoom head, it is set for the actual or closest focal length.
- If the built-in flash is being used, the shutter is locked until recycle has been completed.

System Flash Compatibility

All Minolta xi and i-Series flash units can be used with the 700si, from the compact low/power 2000i, the mid range 3500xi, the Macro Flash Set (ring light type) designed specially for macro photography, and two high power units. These are the 5400xi (-released with the xi-Series cameras) and the latest, the 5400HS, which allows high speed sync (HSS) with the 700si at shutter speeds up to 1/8000 sec.

The 5400-Series models are motorized so the head zooms automatically to the focal length in the range of 28mm to 105mm. Flash output is appropriate to the image area and power is not wasted. You can also adjust the zoom head yourself.

Older AF-Series flash units can also be used with the 700si. These require an accessory Flash Shoe Adapter FS-1100 because the shoe configuration has been changed since the original Maxxum/Dynax 7000/9000 models. These can "communicate" electronically with the 700si, but older Minolta (X and PX) flash

units and those made by other makers for the 7000/9000 do not incorporate identification data. Mount one of these and the camera will shut down to prevent possible circuit damage. To use non-dedicated flash guns or studio systems, you'll need the Vertical Control Grip with its threaded terminal which accepts standard PC sync cords.

Conventional Flash Operation

In conventional flash photography, the camera's exposure system meters the scene and selects an appropriate aperture and shutter speed. With the 700si this can range up to 1/200 sec. unless using the 5400HS flash. When the shutter is released, the flash is triggered; the camera's TTL metering system reads the light reflected off the film surface (called OTF). When the amount of flash is deemed correct, it is cut off by the thyristor.

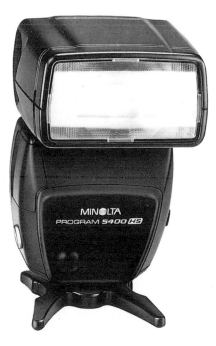

High Speed Flash Sync

Although the 5400HS looks similar to the earlier xi models, it is superior to its predecessors in user control and function. Instead of a MENU button and two multi-function buttons, the 5400HS offers a choice of four separate operating modes: Normal, Wireless, Multi, and Ratio. The function buttons provide access only to the usable modes in each for the sake of simplicity. In addition, the buttons are

Maxxum/Dynax 5400HS

127

High Speed Synchronization
This graph illustrates the technical differences in high speed and conventional flash synchronization. With high speed sync the flash emits multiple pulses of light starting slightly before the shutter opens and continuing until after it closes. This high frequency pulsing over the entire period that the shutter travels allows the complete exposure of the entire film frame at higher-than-normal flash sync speeds. With conventional synchronization, the flash discharges only once, after the first shutter curtain opens completely. This one-time burst is what determines that the flash cannot fire at a speed higher than the conventional flash sync setting in order for the complete frame to be properly exposed.

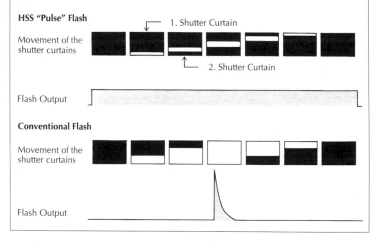

clearly labeled in each mode and all displays are positioned near their respective control to further simplify operation.

The primary claim to fame of the new 5400HS is the HSS feature: it is the only flash gun which will allow sync at up to 1/8000 sec. when used with the 700si. This makes fill flash possible in brilliant sunlight, with fast film and wide aperture, while maintaining proper background exposure, for example.

Surprisingly, HSS is the camera's default setting - it appears when you load batteries until you press the OFF button. Then it performs just like the xi Series.

HSS flash differs from conventional flash by firing a series of high frequency pulses (50kHz) which start before the shutter opens and stops only after the shutter closes. This flat pulse

Shutter Speed	Lens Focal Length	
	24mm	105mm
1/250 s	GN 36	GN 63
1/500 s	GN 26	GN 43
1/1000 s	GN 18	GN 31
1/2000 s	GN 13	GN 22
1/4000 s	GN 9	GN 16
1/8000 s	GN 7	GN 11

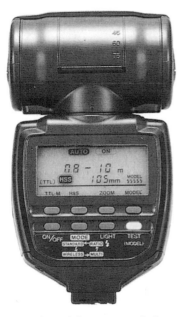

Rear view of the 5400HS Flash unit.

resembles a constant light source so the entire frame of film is evenly illuminated. Consequently, the HSS function of the 5400HS can be used with any shutter speed with the 700si.

Before the actual burst, the system calculates the necessary amount of light which will be required. A brief pre-burst of fixed intensity is fired and the reflected light is read by the honeycomb meter. When the necessary flash power level is determined, the pulses begin to fire.

Note: In Program mode, HSS is automatically activated when the shutter speed exceeds 1/200 sec. In Aperture Preferred mode, you can select any f/stop and the camera will set the corresponding shutter speed. If this is higher than 1/200 sec., the 5400HS automatically switches to HSS mode. In Shutter Preferred or Manual mode, HSS is automatically selected whenever you set a shutter speed of 1/250 sec. or faster. At 1/200 sec. and slower, the system provides only conventional flash exposure in any mode.

High-Speed-Synchronisation (HSS)

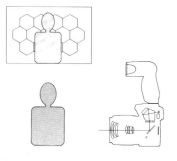

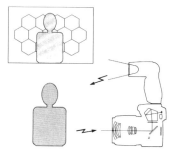

**Minolta 5400HS Program Flash
High Speed Synchronization**

1. The Maxxum 700si measures the subject the instant that it is triggered by the eye-start system or when the shutter release button is lightly depressed. HSS (high speed flash synchronization) is automatically activated when the shutter speed is faster than 1/200 second; in this case, the HSS symbol appears in the viewfinder.
2. The shutter is released.
3. The 5400HS emits a short preflash to meter the subject.
4. The camera calculates the flash output for correct exposure.
5. The mirror flips up.
6. The 5400HS flash fires.
7. The shutter opens, however, at a speed greater than 1/200 second, it does not expose the entire frame at once. Instead, it travels as a slit over the film. Even illumination is achieved by the high frequency flash pulses of the 5400HS flash. This gives the impression that the photograph was lit by continuous light.
8. When the exposure is completed the 5400HS turns itself off.

Limitations of HSS

As with everything, however, HSS has a price. In this case, it is a noticeable reduction in the flash range. The 5400HS reaches maximum output in automatic or manual modes when the zoom head is set at 105mm. A guide number of 177' (54 meters) can be expected only if the sync speed of 1/200 sec. is not exceeded. Under the same conditions with HSS at a shutter speed of 1/250 sec. (only slightly faster than 1/200 sec.), a drastic reduction in guide number is apparent - it is reduced by almost two thirds with the high frequency pulse.

We could list all of the Guide numbers here with shutter speed and focal length as the variables. However, this information is contained in the 5400HS Owners Manual. Suffice it to say, the Guide number drops dramatically at higher shutter speeds, especially with wide angle lenses.

The practical applications of HSS mode are therefore somewhat limited. Frankly, you'll need wide aperture telephoto lenses and faster film to get true value from HSS beyond 1/250 sec. We consider an ISO 400 film and a fast portrait lens most useful for exploiting the advantages of high speed sync flash.

Other Limitations:
- HSS will not operate in bounce flash or in wireless TTL flash.
- If the 700si determines that the light conditions are too dark for HSS to be effective, shutter speeds faster than 1/200 sec. will not be usable.

Nevertheless, you will definitely appreciate HSS capability in outdoor photography, primarily when shooting people pictures.

Modeling Light

One of the disadvantages we found when testing the wireless TTL flash of earlier xi systems was the lack of a modeling light. It was impossible to determine whether undesirable shadows would fall on the background, so positioning the remote head became purely guesswork. This has now been rectified. The same high-speed strobe flash offered by the 5400HS has another useful

application, as a flash modeling lamp. When activated, this helps you to preview the effects of lighting, minimizing the need for costly trial and error shooting.

The modeling light operates in two distinct modes. In Mode 1, a low-frequency series of strong flash bursts is used, which is ideal for portraits or other large subjects. In Mode 2, a high frequency series of low power pulses is fired. Its range necessitates use in close-up work where even fine shadows can be readily detected.

Select the desired mode with the [MODEL] button of the 5400HS; press the [TEST] button to activate the modeling flash. In Wireless use, press the camera's [SPOT] button instead to generate pulses from the off-camera flash. Once you have evaluated the light/shadow relationships on the subject, re-position the flash and try again. After a few tests, you will find the ideal position and should get just the effect intended in the final picture.

Note: If the 5400HS is attached to the hot shoe, the camera will not fire when the modeling light is on. In Wireless mode the shutter can open while the modeling light is flashing, but the exposure will not be correct. With wired off-camera flash, the modeling light is practical when only a single 5400HS is used, as all must be activated simultaneously.

Wireless Remote Off Camera Flash

For off-camera flash without a tangle of sync cords, use Wireless flash mode to control the suitable flash units listed later. The 700si's built-in flash and TTL metering system control flash exposure. In Wireless mode, the accessory flash is controlled by a signal from the built-in head, or another flash gun mounted in the hot shoe.

The 5400-Series flash units can also be used with the Wireless Remote Flash Controller and two off-camera 5400 flash guns for 2:1 or 1:2 lighting ratio. A signal from this Controller then activates the remote units. You can use not only the 5400HS but also the 5400xi and 3500xi (the latter only if combined with one 5400-Series flash). A second signal serves to shut the remote unit(s) off as soon as the TTL system determines that enough light has exposed the film.

Ratio control simply involves controlling the illumination relationship between the two flashes. The default value has the units lighting the subject in a ratio of 2:1: the remote head provides two thirds of the illumination and the on-camera head one third; hence the term 2:1 ratio. This relationship can be reversed so the on-camera flash provides 2/3 and the remote flash 1/3 of the illumination.

When reading the instructions for ratio control, remember this simple rule: the first number in the ratio always refers to the flash furthest from the camera. For the majority of situations, you'll find the 2:1 ratio most pleasing.

Tips for Wireless Flash Photography

We could probably write another entire guide to using the 700si in combination with the new 5400HS for creative photography. However, the following hints must suffice for now:

- In wireless mode, shutter speeds faster than 1/60 sec. cannot be selected.
- Reduce the brightness of your surroundings as much as possible to maximize the range of the signal from the on-camera flash
- The sensor which detects the signal is next to the flash unit's red AF illuminator lamp; position it so that it is within sight of the camera.
- The flash signal in the viewfinder will blink if output was adequate to provide correct exposure. If not, use faster film or move it closer to the subject.
- When positioning flash units, place them in front of the subject so the reflected light is seen by the camera. If set up to light only a small part of the subject, that area will be overexposed.
- When using off-camera flash, it is best not to position it more than 45 degrees off subject center. This will allow full coverage and accurate exposure.
- When softer light is desired, an optional accessory can be useful. These include the *Stofen Omni Bounce*, *Micro Apollo* from Wescott, or any of the *LumiQuest* light modifiers.

Multi-Burst Mode

With multi-flash mode you can create several flash images on the same frame, useful in a photographic study of a moving object. In this mode the flash will fire several bursts in rapid succession; the frequency and number are manually selectable.

Full use of this feature (somewhat esoteric for most) is beyond the scope of this Guide. You will need to study the Owner's Manual and experiment. There is no alternative to experience for learning to create the effect you want. Keep notes for each frame so you can later repeat the most successful technique. Refer to the table in the Manual for the fastest shutter speeds you can set with the various combinations of frequency and flash repetition.

5400HS Flash Accessories

The 5400HS comes complete with the MS-2 mini-stand so you can set up the Wireless flash on a flat surface. The stand has a tripod socket so it can be mounted on a tripod or light stand as well. The following accessories are also available for the 5400HS:

External Battery Pack EP-1 Set: The EP-1 takes 6 C-size alkaline or NiCd cells and attaches directly to the external power terminal of the 5400HS. It reduces the recycle time while increasing the number of flash exposures.

Bounce Reflector III Set: This compact umbrella attaches to the 5400HS to provide an excellent bounce surface. With bounce lighting, soft, shadow-free effects can be obtained indoors or out. The typical harsh flash light effect is reduced. The burst is aimed at a larger, diffuse surface and reflected back. TTL flash exposure controls the duration for accurate results. The reflector can be mounted and folded up in no time and takes up little room in a camera bag.

This is the result of wireless remote control: The 700si's built-in flash ⇨
activates the 5400HS (positioned to the left) without the need for a sync cord or TTL connecting cable.

Off Camera Cables and Connectors: To control the flash position and lighting angle, attach one end of an OC-1100 cable to the 5400HS' accessory terminal and the other to the camera's hot shoe. Unlike wireless flash, full 700si/5400HS capabilities are retained. If the flash is to be mounted on a tripod, use Off-Camera Shoe OS-1100. For multi-flash operation, the triple connector TC-1000, Cable EX and Cable CD can also be used. This TTL cord system can also be used to connect and sync (via cable) older flash units such as the 3200i and 5200i to the 700si.

Flash Shoe Adapter FS 1200: Because the hot shoe configuration differs from the older Maxxum/Dynax cameras, this device is required in order to mount older dedicated flash units (AF-Series) on the 700si.

NiCd Charger NC-2: Unlike alkalines, Nickel-Cadmium batteries can be recharged for repeated use. They provide faster recycling and superior low temperature response but fewer flashes per charge. The NC-2 is a compact unit which can recharge the four batteries (included) in eight hours. (However, aftermarket systems offer special "quick charge" batteries which complete charging in 2 hours or less in a suitable unit).

Maximizing Flash Performance

If fast recycle times and a long life are critical, the choice of the appropriate power cells should be made carefully. The marked differences between cells can be seen on the number of flashes per set. For example, if alkaline batteries produce 150 flashes, rechargeable NiCds will only manage about half. (Carbon-zinc batteries are not recommended for use with flash units). The actual numbers can change depending on the model in use and other variables, but the tendency is always the same.

Recycle times show a completely different picture, however. If fresh alkalines take nine seconds to recharge a flash, fully-charged NiCds will only require five or six seconds.

If the highest possible power output of the flash is required, one should wait a few seconds after the ready light goes on because many units are only 75% charged at this point. This makes the recycle times sound better but could result in underexposure.

Note: *Eveready released "photo optimized" lithium AA batteries in 1993, boasting all of the advantages (and high price) of this formula. Since the voltage ranges from 1.7 to 1.8v however, Minolta does not recommend these for the 700si, 400si or their flash units. On the other hand, Eveready offers to repair or replace any equipment damaged by these batteries. As of January 1994, no claims had been filed.*

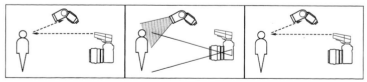

The camera's control element triggers the start signal.

The off-camera flash begins to fire and the camera's TTL flash metering system monitors the amount of light striking the film.

The control element sends the stop signal when the proper exposure level is reached.

Minolta's flash units can be controlled without the need for cables connecting the equipment. With the small built-in flash plus a larger unit such as the 5400HS, (and ratio control) one already has the makings for a basic studio lighting system.

Having reviewed some of the more advanced features, let's return to consider standard flash operation.

Flash in Program Mode

Control: *Set camera to "P", turn accessory flash unit on or raise built-in head.*

When the flash head is lifted or any dedicated accessory flash is mounted on the 700si's hot shoe, it will fire automatically in Program mode. A shutter speed between 1/60 and 1/200 sec. is automatically set. The camera's TTL metering system ensures accurate results making the entire procedure simple and reliable. But remember: the **flash will not fire if the 700si has been shifted to "PA" or "PS"** by turning one of control dials; press the [MODE] button to return to the standard Program.

In backlit conditions, or when the forced-flash button (denoted by a lightning bolt) is pressed, fill flash is automatically delivered. Ambient light exposure of the subject is reduced as is flash brightness to maintain proper exposure. This is highly useful in outdoor situations, producing a pleasing overall effect.

If you have mounted a 5400HS flash unit, high speed sync flash is automatically enabled when a shutter speed faster than 1/200 sec. is set by the system. This generally occurs only in brightly lit conditions because the range of HSS flash is quite short otherwise.

Flash in Semi-Automatic Modes

Control: *Set the 700si for "A" (Aperture Preferred) or "S" (Shutter Preferred) mode by pressing the [MODE] button while turning either control dial. Raise the built-in head or set accessory flash to TTL mode.*

As expected, the photographer sets the desired aperture in [A] mode and the 700si automatically selects a sync speed (the fastest between 1/200 and 1/60 sec. depending on ambient light levels). The flash is triggered for every exposure. In Aperture Preferred

mode, you can control the flash range and depth of field by choosing a suitable f/stop.

Outdoors or in strongly backlit situations, flash brightness is reduced for pleasing subject exposure. The background will be up to 1.5 stops brighter. Indoors, flash brightness is set to normal rating, while the shutter speed is controlled to reduce ambient light brightness by one stop for the most satisfactory results.

In [S] mode, any shutter speed can be selected from 1/200 sec. to 30 sec. by the photographer. (Use a tripod if longer than 1/60 sec.). The 700si's Expert Exposure system will then select the appropriate aperture. If a fast shutter speed is chosen, the camera automatically reverts to the highest sync speed of 1/200s unless the 5400HS flash is in use, allowing HSS at up to 1/8000 sec.

In Shutter Preferred operation, flash brightness is reduced to produce a pleasing subject exposure. However, the background will be up to 1.5 stops **brighter** than the subject.

A Note of Caution: While the Expert honeycomb metering system is highly successful in flash metering, it cannot fully recognize a pure white or all black subject. Unless Exposure Compensation is input, some underexposure and overexposure (respectively) will occur due to the high and low reflectance in the examples above. With a small subject surrounded by snow for example, we find a +1 compensation (use the [+/-] button and a control dial) useful when shooting slide film which requires accurate metering.

Minolta recommends Shutter Preferred flash mode for daylight conditions. In normal indoor conditions, the aperture will remain wide open providing little depth of field.

↩ **Extremely backlit situations generally benefit from the use of fill flash, automatically calculated by the 700si.**

Slow Sync Flash Effects

Control: *In [P], [A], or [S] mode, press the 700si's [SPOT] button when flash is activated. This sets slow-sync flash to ensure that the background is nicely exposed.*

In slow-sync photography, flash brightness is automatically reduced by 3/4 stop, and a slow shutter speed is set. At the higher shutter speeds, the background would be rendered relatively dark. In order to avoid this, long exposures can be used to allow the ambient light of the background to register on film. A tripod is required unless you decide to hand hold the camera for special effects: the flash will ensure that the subject is sharply rendered while the surroundings will be blurred.

Note: *In [S] MODE slow sync flash is not generally recommended as background exposure will be favored and the subject may be underexposed.*

Flash Exposure Compensation

Control: *Press and hold the [+/-] and flash control button simultaneously. Turn either control dial until the compensation factor appears in the LCD panel. Release the buttons to enter the factor.*

In our experience, the primary use of flash compensation (with the built-in head or a dedicated unit) is to reduce flash power in outdoor use. While the system will automatically produce pleasing fill, some consider the results preferable with a -.5 compensation factor when using slide film. Experiment to establish your own preferences.

You should first shoot without compensation to familiarize yourself with the results produced automatically. Use slide film because the effect can be varied by the lab when making prints from negatives. If you routinely find the subject too bright or too dark for your preferences or want to try unusual effects, experiment with flash compensation.

Note: *If your subject is primarily black or white, however,* **use**

standard Exposure Compensation to correct for the low or high reflectance – *not Flash Exposure Compensation*. Press only the *[+/-]* button and turn one of the control dials to input a + or - compensation factor; perhaps +1 when the bride fills the frame. This may well be unnecessary with print film. If shooting slides, experiment with white and black subjects first; you will soon know when this precaution will be necessary. (See Chapter 6 for additional hints on exposure control).

Manual Flash Photography

Control: Press the [MODE] button while turning either control dial until "M" appears on the LCD panel.

When the 700si is switched to fully manual operation, you set both aperture and shutter speed for flash photography. The flash output is determined by the 700si's meter and regulated by its TTL flash control system. Now you can manually adjust the ambient exposure by varying the combination selected. You can also control the flash brightness by using the camera's flash exposure compensation feature. When using the 5200i, 5400xi or 5400HS flash units, these can also be switched to manual operation. The level can then be adjusted for special applications.

If you are working with non-Minolta or studio flash units (attached via a PC sync cord), the 700si must be used manually. Make sure that the shutter speed does not exceed 1/200s, since the flash will not expose the whole frame otherwise. We recommend the use of Maxxum/Dynax system flash units. Their automatic features, TTL metering, and extra capabilities make these the ideal choice. Accurate exposures are practically guaranteed while user override remains available.

However, you may wish to use high power studio flash systems instead. If so, you'll need the Vertical Control Grip which contains the necessary PC sync cord terminal. Manual flash photography can be an advantage if you have some expertise with such systems and with flash metering using an accessory device like the Minolta Flash Meter IV. However, since such work is beyond the scope of this Guide, we'll move on to some final hints for TTL flash use with dedicated units.

Tips for Flash Photography

Guide Number

The power of every flash unit is given as a Guide number (GN) in reference to a certain film sensitivity (usually ISO 100). The higher this number, the higher the flash power behind it. In comparing flash units, remember that doubling of the guide number actually results in a **quadrupling of power**.

Do not make the assumption that a flash unit with a guide number of 39.6' (12 meters), for example, will actually provide that range. Perhaps in a hypothetical "ideal" situation this will be the range, but in real world photography much light is lost. Consider the guide numbers as merely a comparison when shopping for an electronic unit.

Indirect Flash

One way to improve the lighting effect is to bounce flash off the wall or ceiling. As the bounce area is large, the flash illumination becomes soft and evenly distributed. The light does lose a considerable amount of power because of diffusion and the longer route from flash unit to the ceiling and then to the subject. By merely doubling the distance, the intensity is reduced to a quarter because light loses power with the square of the distance (Inverse Square Law).

Hence we recommend one of the 5400 series flash units with their high guide number of 177' (54 meters); this is among the highest of any system flash unit available for any brand of camera. But even one of the mid-priced Maxxum/Dynax models should have adequate power unless the ceiling is much higher than usual. Look for a pure white surface to use for bounce flash. Otherwise, an unpleasant color cast can be expected.

Tip: For softer light without bounce, try facial tissue over the flash head in varying thicknesses to reduce the harshness. Even more useful are some of the light modifying devices mentioned earlier. If you frequently use a camera mounted accessory flash unit, one of these diffusers, small soft boxes, or add-on bounce surfaces will certainly produce superior results.

Stroboframe® Flash Brackets

Stroboframe brackets offer a unique solution to many flash problems. These innovative flash brackets have been manufactured and successfully marketed for years by The Saunders Group in the United States.

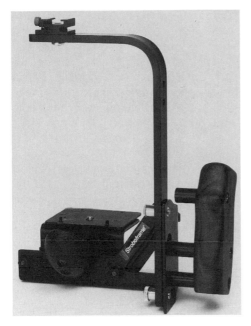

Stroboframe® System 2000 Flash Bracket

The basic principle of the brackets is the sturdy, light-weight aircraft aluminum frame with ergonomically molded grips. Electrical or mechanical cable releases may be accessibly mounted in or near the side grip. The top bar of the bracket features a 1/4"-20 screw for attaching standard flash mounts. At the base of the bracket is a platform which holds the camera securely. Beneath that is an comfortable, ergonomically-shaped palm grip.

Many professional photographers prefer to use off-camera flash because it offers better lighting control. Direct, on-camera flash is often harsh and unnatural with heavy, hard-edged shadows. When the flash is too close to the lens, "red-eye" can occur. This is a condition caused by the light from the flash reflecting from the inner eye, resulting in an unattractive, "blood-shot" appearance. One solution is the use of bounce flash, but this technique has its own problems and limitations. Factors such as ceiling height, texture or color can often cause unpredictable results.

A simple way to avoid undesirable results in flash photography is a well-designed bracket such as Stroboframe. Using a bracket raises the flash to the correct height for a natural lighting effect. Shadows fall behind and below the subject and harsh edged

"ghost shadows" are eliminated, even when the subject is close to the background.

One very interesting benefit of using a Stroboframe bracket is that the camera platform can be rotated quickly and easily between horizontal and vertical formats. The advantage is that the flash remains, at all times, centered above the camera in the same position for high, natural-looking lighting. Also, time-consuming, renewed positioning of the flash head is not necessary.

Using Fill Flash

When shooting outdoors in morning or afternoon, your subject will be backlit if you are shooting into the sun. The use of fill flash can even out the exposure between subject and background for a much more satisfying overall result. Even if the sun is to the side, fill flash is helpful for softening shadows which may obscure subject detail. In general, fill flash produces a more even foreground illumination, more saturated colors and sharper detail. We have reviewed the use of fill flash with the 700si and dedicated units. If you have yet to try fill outdoors we strongly recommend it for most subject matter from people to still lifes.

Minimizing Red Eye

We have previously discussed this problem and its cause. Here are a few hints for minimizing the effect:
- Use off-camera flash raised well above the lens axis
- Use a wide angle instead of telephoto lens, if appropriate.
- Ask your subjects to avert their eyes.
- Brighten the room as much as possible. (The more the pupils contract, the less the extent of reflection from the arteries of the inner eye.)
- Use the red-eye reduction mode of the camera.

Minolta Lenses for the 400si and 700si

As expected with any SLR system, Minolta offers a full range of lenses for the 400si and 700si. The current A mount is not compatible with the earlier manual focus lenses because the old, mechanical technology could not be made to fully interface with the Maxxum/Dynax computerized control. While some have criticized manufacturers who have taken this route, we consider it to be highly logical. We see it not as "planned obsolescence", but as an essential part of the transition to technology which allows the engineers to incorporate past and future developments for the benefit of the photographer.

Wide Angle Lens Technology

In order to be able to offer focal lengths shorter than the depth of the camera body, designers make use of an optical trick: retrofocus lenses combine a diverging front element and converging rear element. The diverging light rays are intercepted by the rear element which causes them to focus at a shorter distance from the lens, precisely on the film plane.

The following briefly describes the wide angle lenses currently available for the Minolta 400si and 700si, with a selection from the moderate to the more extreme fisheye. Start with a standard 35mm wide angle, or better yet a 28mm. After gaining some experience with wide angle effects, you can decide whether you really need the more pronounced perspective of the ultra wides.

AF Fisheye Lens

At the extreme end of the spectrum you'll find the AF 16mm f/2.8 Fisheye with an angle of view of 180 degrees. The coverage of this lens is so wide that one has to be careful not to include the tips of his shoes in the frame. And if the sun is at the side or behind you, expect to have your shadow recorded on film. One

solution is to trip the shutter with the self timer (with camera mounted on a flexible tripod such as a Benbo) and move some distance from the equipment.

Because of the expansive field of view, take extra care not to include extraneous elements. In fact, this lens definitely requires

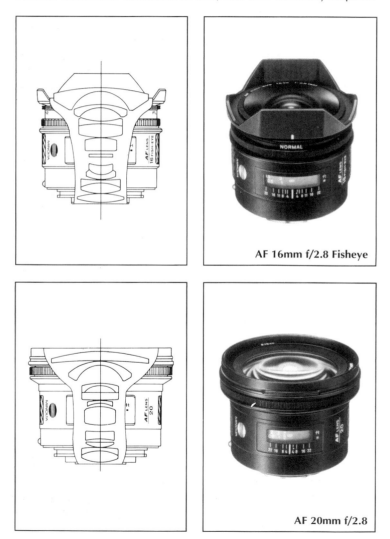

AF 16mm f/2.8 Fisheye

AF 20mm f/2.8

careful composition because the risk of taking pointless pictures (with many elements and no center of interest) is great. The fisheye effect alone does not "make" a picture; indeed, the effect can be overdone until the novelty wears off.

Do note that this is a "full frame" fisheye. Instead of producing the traditional circular image, it records only a rectangular portion of the full 180 degree view. But straight lines are still reproduced as bent (or bowed) unless they pass exactly trough the center of the image. This effect is not caused by an error in engineering but rather by the typical curvilinear design. It occurs to some extent with all wide angle lenses. The shorter the focal length, the more pronounced the barrel distortion, or straight lines bowing outward.

This specialty lens is recommended only for advanced photographers who already own a full range of focal lengths and require a fisheye for special effects. Use it to record an entire room, or lie on your back and shoot upwards, for example - among a huddle of football players, a stand of trees or a circle of poppies. The results will be unconventional, but particularly striking.

Minolta's AF 16mm Fisheye has a built-in filter wheel with four integral filters which can be rotated into place; the one of clear glass should be in use when no filtration is desired. The others include orange (for black and white photography), magenta (for color pictures under fluorescent tubes) and blue (for use with tungsten lighting).

Ultra Wide AF Lenses

Unlike its fisheye lens, Minolta's other wide angle AF optics are corrected to provide a rectilinear image without extreme barreling. Hence, distortion is kept within acceptable limits so lines, even at the edges of the frame, are rendered with substantial accuracy.

This is true for the AF 20mm f/2.8, which offers a coverage of 94 degrees. That's only about half the fisheye view but is quite adequate for the vast majority of pictorial and technical applications. Noteworthy with any ultra-wide lens is the extensive depth of field at any aperture. By f/16, the AF 20mm will provide acceptable sharpness from a few inches to infinity if you focus at a point roughly a third of the way into the scene.

Tilt the camera and another trait of wide angles becomes obvious. Vertical lines seem to converge, or lean inward, out of plumb, while the edges of a horizon bow upward. In some circumstances, this characteristic can be used for creative purposes, but most photographers prefer the more "normal" rendition. For utmost accuracy, mount the 700si on a tripod and use one of the bubble levels (such as the HAMA) available from a photo retailer. These fit into the hot shoe and guide camera alignment.

By a broad definition, the AF 24mm f/2.8 also belongs in the category of ultra wide angle lenses with its coverage of 84 deg. A photograph taken with 20mm to 24mm focal lengths is unmistakable because of its expanded spatial perspective. This causes the foreground to become more prominent (less than pleasing for portraits) while more distant objects are rendered smaller than the eye perceives. Focus on a group of wildflowers, for instance, and you can include the expansive sweep of blossoms receding toward the horizon for an appealing picture. When used skillfully, a dramatic effect can be achieved producing some very successful pictures.

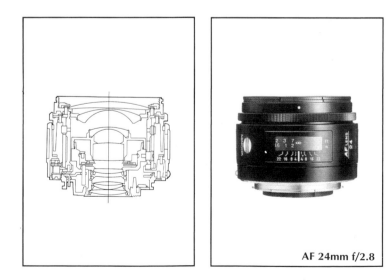

AF 24mm f/2.8

Wide Angle AF Lenses

Minolta offers two choices in the 28mm focal length: the fast AF 28mm f/2.0 and the slower AF 28mm f/2.8. At 28mm, the lens offers an angle of view of 75 degrees roughly comparable to that

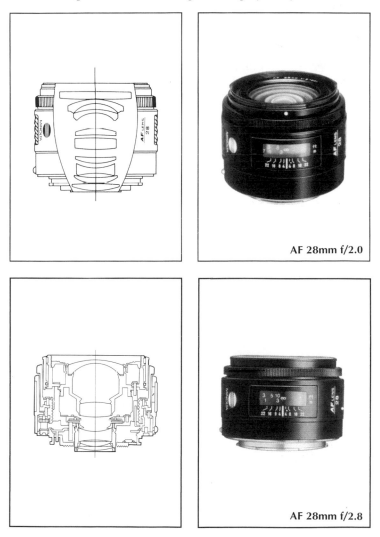

AF 28mm f/2.0

AF 28mm f/2.8

of your own two eyes. Hence, the wide angle effect is subtle, with the more "natural" perspective considered more pleasing by some. (Actually, perspective is a function of camera to subject distance. Hence, our comments relate to comparisons made while shooting with various focal lengths from the same position).

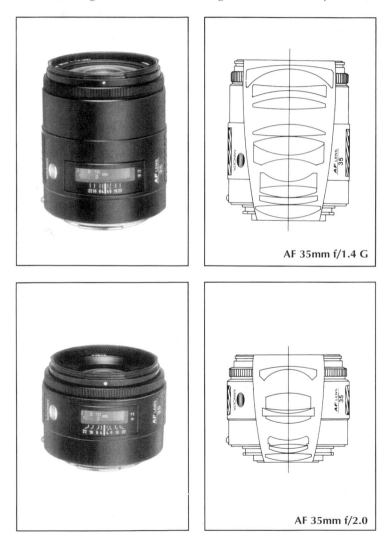

AF 35mm f/1.4 G

AF 35mm f/2.0

The AF 28mm lenses are practically distortion-free but still offer a noticeable wide angle effect in comparison to the 35mm lens. Without the exaggerated perspective, it is probably the first wide angle lens which should be acquired. The "fast" 28mm f/2.0 is intended for available light photography. It has a complex optical construction consisting of 9 individual fixed elements. The 28mm f/2.8, in comparison, offers slightly less weight (6.5oz. [200g] instead of 10oz.[285g]) and is slightly more compact.

In spite of the above, many photographers want a 35mm lens, often using it as their standard lens for numerous situations. With the AF 35mm f/1.4 G (with an aspheric element for superior sharpness) and the AF 35mm f/2.0, Minolta offers two different lens speeds in the modest wide angle range. Both have an angle of view of 63 deg. not significantly different from a normal lens's 47 deg. angle. Thanks to its reduced wide angle characteristics, this lens is easy to use. The resulting pictures are rarely recognized as typical wide angle shots and can almost be attributed to a 50mm lens.

The faster version, at 16-1/2 oz. (470g), is almost twice as heavy as the AF 35mm f/2.0 which only weighs 8-1/2 oz. (240g) – a fact that photographers who are often on the move should not discount. On the other hand, those who prefer using available light (without flash) will undoubtedly reach for the 35mm f/1.4.

Keep in mind that the wide angle pairs differ in maximum aperture by only one stop. This is true for both the 28mm and 35mm duo. You gain only a single shutter speed or aperture stop. The same can be achieved by choosing a higher speed film (ISO 200 instead of ISO 100, for example). While this may be a factor for those shooting slides, today's exceptional color print films make this merely academic with prints of 8x12 or smaller. For larger prints or professional work, the more expensive faster lenses may be a suitable investment as their highly corrected optics produce superior resolution.

"Normal" Range Lenses

These days, the 35-80mm zooms are replacing the 50mm lens more and more often. This has become the standard zoom as it incorporates the 50mm focal length considered "normal" in

35mm photography with its 46 deg. angle of view which approximately corresponds to the area seen by a human eye.

This means that a picture taken with a 50mm focal length appears very much like we recall the scene. Since no wide angle or telephoto effects are incorporated into the image, it seems com-

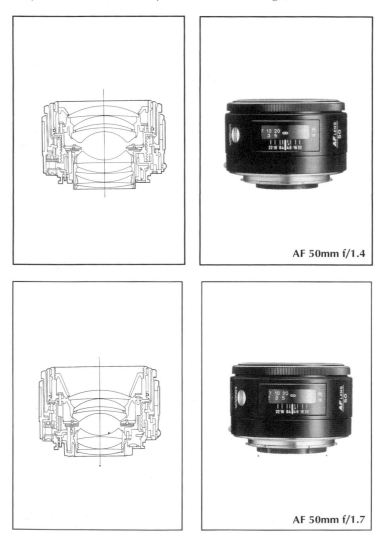

AF 50mm f/1.4

AF 50mm f/1.7

monplace; simply normal. This fact is not necessarily a disadvantage because it gives the photographer the chance to place more emphasis on exercising his own vision in viewpoint, subject selection and composition. The viewer sees what the photographer wants him to see, not the effect created by an unusual focal length.

Compared to zooms which encompass the 50mm focal length, the normal lens can claim the advantages of all fixed focal length lenses: compactness, speed and optical quality. Minolta offers two variations: an AF 50mm f/1.4 and an AF 50mm f/1.7. The AF 50mm f/1.4 offers a half stop wider aperture, but at a weight/price penalty due to size and a more complicated construction. The autofocus speed is worth considering as well. The faster 50mm f/1.4 version takes 0.6sec. to focus from 18" (0.45m) to infinity; the 50mm f/1.7, on the other hand, only needs 0.24 sec. It focuses nearly twice as fast, as there are fewer elements of lighter weight which must be moved by the motor.

Macro Lenses

The photographer has several options for taking the 700si into the realm of close-up photography. First are the two macro lenses,

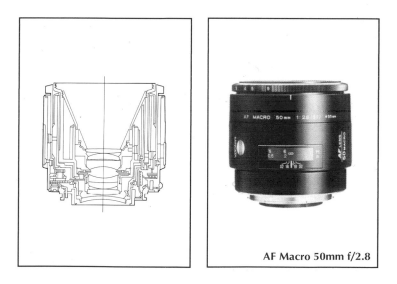

AF Macro 50mm f/2.8

the AF 50mm f/2.8 and the AF 100mm f/2.8 Macro. Both incorporate the amount of extension needed to focus adequately close to render the subject lifesize on the film (1:1 reproduction ratio) without additional accessories.

The extra extension is not the only feature that makes these

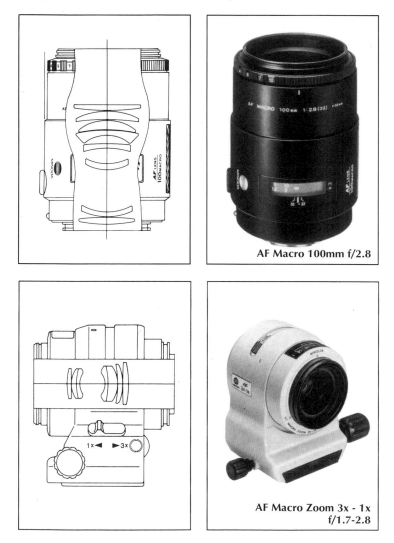

AF Macro 100mm f/2.8

**AF Macro Zoom 3x - 1x
f/1.7-2.8**

lenses particularly suitable for close-up work. The entire optical construction is of the highest quality, making these suitable when distortion free, flat field, and high resolution images are necessary. This means that stamps or maps, for example, can be reproduced exactly, without curvature or reduced sharpness in the corners. Though somewhat heavy, these macro lenses are also excellent for use in conventional photography focused at medium distances or infinity.

Depending on the intended use, one will select different focal lengths in macro lenses. If most of the work is done on a copy stand, the shorter focal length is recommended. (For a budget priced alternative, consider the AF 50mm f/3.5 Macro, released just before press time).

This is because fairly large subjects are to be covered from relatively small distances as the stand's column has limited height. Conversely, macro nature photography benefits from the longer focal length, which offers a greater camera to subject distance. This approach prevents the photographer's shadow from covering the subject, allows flash or reflectors to be used conveniently, and is less likely to frighten a live subject.

Minolta also offers an AF 45-53mm f/1.7-2.8 3x-1x Macro Zoom for the absolute macro specialist. This lens is designed specifically for images with reproduction ratios between 1:1 and 3:1. Subjects are reproduced from life size to three times life size on the film frame.

Minolta has made the most of the technical possibilities offered by this camera/lens combination. Full information transfer between the lens and camera is maintained, preventing loss of automation including autofocus. The theory that this lens is specifically meant for the specialist is supported by the subject distances: between 1.6" (25mm) at 1:1 and 1" (41mm) at 3:1. You would not be able to get this close to your subject normally, so its use is confined to technical applications, for the most part. The camera/macro zoom lens should be mounted on a firm tripod, attached with the mounting collar which allows the entire assembly to rotate.

Short Telephoto Lenses

Minolta's entire line of fixed focal length AF lenses has proven to offer high standards of performance. This is particularly true of the telephoto range comprised of "fast" lenses suitable for professional applications.

The first is the AF 85mm f/1.4 G which provides minimal depth of field at f/1.4, exemplifying the concept "selective focus". For all intents and purposes, only the plane in actual focus is rendered sharp. Precise focusing on the essential subject detail is critical, especially in closeups. For portraits, for which this lens is particularly well suited, the following ironclad rule applies: focus on the eyes! Pay careful attention since the eyes will be out of focus (at wide apertures) if you allow AF to select the tip of the nose as its target.

The above must also be taken into consideration with the AF 100mm f/2.0, another classic portrait lens, producing pleasing perspective in a head and shoulders rendition from a comfortable working distance. We're not suggesting that these short telephotos are of interest only to the portrait photographer. On the contrary, one of these fast lenses should be part of an advanced amateur's basic set of equipment.

AF 85mm f/1.4 G

Any subject that requires a greater shooting distance, or circumstances requiring available light exposures, can often can be handled with one of these lenses. Examples of such situations are candid snapshots, photo journalism, basketball, theater, and a circus ring. An ISO 400 to 1000 film may be required but this is

AF 100mm f/2.0

AF 135mm f/2.8

still preferable to ISO 1600 or 3200, which become essential with slower zoom lenses of f/3.5 to 5.6 in hand-held work.

When deciding for or against fast lenses, remember that the 700si can only use its higher (to 1/8000 sec) shutter speeds on bright days, with medium speed film and wide aperture lenses. We have yet to encounter a situation where even a 1/4000 sec. shutter speed could be used with a zoom whose maximum aperture is f/5.6 or even f/3.5.

Longer Telephotos

Another suitable choice is the AF 135mm f/2.8 whose slower speed is reflected in the lower price. It is the first "true" tele lens discussed so far. While the previous lenses are useful for nearby subject matter, from intimate landscapes to portraiture, the 135mm is the first lens where the telephoto effect becomes noticeable.

As the focal length increases, the angle of view narrows while perspective is compressed, making objects seem closer together than the eye perceives. This effect is also apparent, and even more so, with the longer Minolta lenses: AF 200mm f/2.8 APO G, AF 300mm f/2.8 APO G and AF 600mm f/4.0 APO G.

A feature of the AF 200mm f/2.8 APO G is the focus limiting ring, which permits the maximum and minimum focus range to be selected. If, for example, a subject will remain nearby, at a distance of 15' or less, the ring can be adjusted accordingly, preventing the AF system from searching the entire range from 8' to infinity, for example. This provides focus more quickly, especially appreciated with moving subjects.

The first two elements of the AF 200mm apochromatically corrected tele lens are made of AD (anomalous dispersion) glass causing all wavelengths of light to focus on the same plane: the film. The use of low dispersion glass provides a substantial improvement at wide apertures: in image sharpness, contrast, color fidelity, resolution and freedom from color fringing at the edges of a subject (noticeable under high magnification).

An amazing, and expensive, tele lens especially suited to sports and wildlife photography is the AF 300mm f/2.8 APO G, which offers fast focusing because of its internal focus mecha-

nism. This means that a few internal elements are moved to perform the focusing function, rather than the entire optical formula, making the process faster. The lens' physical size also remains constant for better balance when mounted on a tripod. The AF 300mm f/2.8 APO includes elements made of low dispersion

AF 200mm f/2.8 APO G

AF 300mm f/2.8 APO G

(AD) glass for fine image quality even at f/2.8. A built-in hood and tripod mounting collar are standard equipment with this hefty telephoto.

A true "super telephoto" lens with an extremely wide maximum aperture is the Minolta AF 600mm f/4.0 APO G. It includes the same focus lock ring described with the 200mm, elements made of AD glass, a built-in lens hood and a tripod mounting collar. The latter is an absolute necessity given its weight of 194 oz (5300g).

In order to allow the use of small (relatively inexpensive) filters, the AF 300mm and 600mm APO accept rear mounted filters which slip into an opening ahead of the mount. Included with the lens are a clear filter plus a yellow, orange and red (for black and white photography), a 4x ND (neutral density) which reduces light transmission by two stops, a skylight filter and the two conversion filters: 85 and 80B for daylight shots on tungsten film and vice versa.

The AF 600mm f/4 APO G super telephoto also comes with a super high price. Comparable to that of a sub compact car, this lens will remain unattainable for all but the most affluent and professional sports or wildlife photographers.

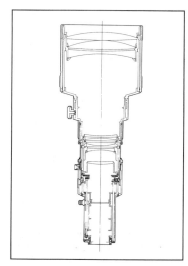 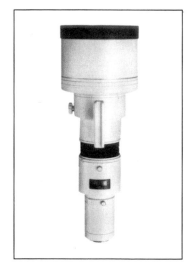

AF 600mm f/4 APO G

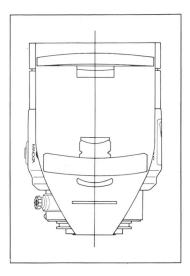

AF Reflex 500mm f/8

An Affordable Alternative

The AF 500mm f/8.0 Reflex (mirror) lens is a much more economical alternative, which is capable of satisfactory autofocus performance in spite of the small aperture. Since it only weighs 23-7/16 oz. (665g), it can be hand-held comfortably – at 1/500 sec. or higher shutter speed to minimize the effect of vibration. Highly compact, the AF Reflex uses lightweight mirrors to fold the light path (plus two optical elements) keeping size, weight, and price modest. This strategy allows a long focal length to be packed into a relatively short barrel, roughly the size of a conventional 135mm lens.

Because of its unique design, it is impossible to build a diaphragm into a Reflex/mirror lens. Consequently, the aperture is fixed at f/8, precluding the possibility of stopping down to vary depth of field. Thankfully, exposure can be controlled by adjusting the shutter speed in Manual mode or dialing in exposure compensation in auto modes. Because any out of focus highlights are rendered as donut shaped instead of the familiar solid blobs, not everyone will appreciate a mirror lens. We recommend discussing the pros and cons with a knowledgeable photo retailer who can provide guidance as to the suitability of the AF 500mm f/8 Reflex to your own photography.

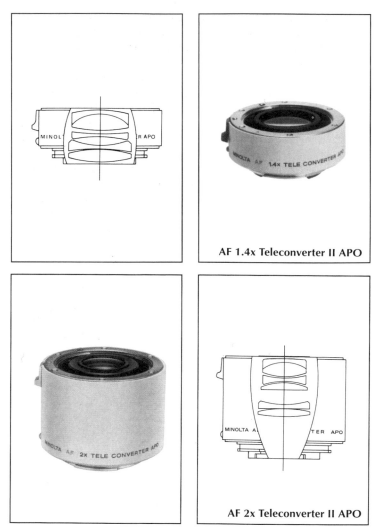

AF 1.4x Teleconverter II APO

AF 2x Teleconverter II APO

Teleconverters

Minolta offers two AF teleconverters for the three AF APO G lenses. The AF 1.4x APO and the AF 2x APO extenders are designed specifically for the 200mm to 600mm tele-lenses, increasing their focal lengths by 1.4 and 2 times, respectively. As

the chart will indicate, a teleconverter reduces light transmission. The 1.4x converter reduces the "speed" of a lens by one stop and the 2x by two stops. Only half or a quarter of the light, respectively, reaches the film.

This disadvantage is not always a significant factor with the fast tele lenses which maintain respectable values, especially with the AF 1.4x APO converter. A 280mm f/4.0 (200mm f/2.8 plus 1.4x teleconverter) or a 400mm f/5.6 (200mm f/2.8 plus 2x teleconverter) are still relatively "fast" lenses for the focal length, competitive with some others in this range.

A converter magnifies the size of the image produced by the lens but increases the effect of optical aberrations as well. Conventional wisdom suggests that a lens should be stopped down at least two stops when using a converter to provide high image quality. But since Minolta matched these converters to the optics of their three APO tele lenses, the combination is a fully compatible optical system that is capable of respectable results even at the widest apertures.

The following combinations are possible:

Lens	+ 1.4x converter	+ 2x converter
200mm f/2.8	280mm f/4.0	400mm f/5.6
300mm f/2.8	420mm f/4.0	600mm f/5.6
600mm f/4.0	840mm f/5.6	1200mm f/8.0

Note: *When using the 2x teleconverter with the 600mm f/4.0, the autofocus system is disabled because performance would suffer given the limited light transmission to the sensors.*

Zoom Lenses - xi-Series vs. Non-xi

Besides its conventional AF lenses, Minolta also offers a series of "xi" designated zooms with additional features. Since most of these also are available without the "xi" distinction, the question of which type to purchase is worth considering.

Significant features of the xi-Series are a built-in motor and micro computer. While Minolta's other lenses include a ROM-IC

(permanent storage), the xi lenses have their own 8-bit micro computer which offers more options in the realm of data gathering and transmission than a read-only chip. And the motor in the lens enables powered zooming by turning the control ring to the left or right.

Another important feature is Image Size Lock. Set the desired framing and the focal length is automatically adjusted (as the subject moves) to maintain the pre-set image size. (Make sure that the Eye Start switch on the 700si is set to ON.) Select a suitable focal length by zooming to crop out distractions. Then press the shutter release to take a series of pictures. The system will maintain a consistent image size **as long as you maintain pressure on the lens' function button.**

Image Size Lock Limitations:

- Image Size Lock may not be able to accurately track high speed subjects.
- If the subject is too small or too far away, it cannot maintain consistent image size.
- This feature operates only with focal lengths shorter than 50mm
- If either end of the zoom range is reached, the lens will stop zooming until the subject returns to the usable range.

The built-in motor has another essential function besides zoom control: powered manual focusing. Pull the zoom ring back and turn it to the left or right. The AF motor will then drive the focusing elements of the lens. The speed of focus change is variable. Depending on how far to the left or right the ring was turned, the adjustment will be faster or slower.

Combined with the **CHILD CE** or **Sports Action 2** Expansion Cards and xi-Series zoom lenses, the 700si also offers Advanced Program Zoom. In APZ the focal length is automatically adjusted to provide the best framing with a moving subject. The amount of magnification can be preset in 5 steps, depending on whether you want tight framing or not. The system can immediately measure the distance to the subject and select an appropriate focal length, varying it as required to maintain suitable framing.

Overview of xi Zooms

Minolta offers the following xi zooms, virtually identical to its conventional AF lenses in all other respects: AF xi 28-80 f/4-5.6, AF xi 28-105 f/3.5-4.5, AF xi 35-200 f/4.5-5.6 "Macro", AF xi 80-200 f/4.5-5.6 "Macro", and the AF xi 100-300mm (non-APO) f/4.5-5.6 "Macro".

Although intended to make photography as simple as possible, the auto-zooming functions may well work against the creative photographer if they encourage laziness. The less one thinks about a subject, the less impressive the picture will be. And the possibility of achieving a unique, creative viewpoint (or framing) will become less and less likely. Hence, in our estimation, these zooming functions are intended for taking average pictures and not for creative image making.

Frankly, we consider the xi features redundant since handling is not significantly improved. With the reliable AF and exposure system of the 700si, varying framing is one of the few remaining "chores" the photographer needs to retain. Besides, APZ requires an Expansion card and some programming to achieve effects easily equaled without the additional time and expense.

We consider Image Size Lock most useful when you lend the 700si to a spouse or child without photographic interest. In such cases, it may be appreciated, although system-selected framing has not proven to match the desires of an experienced photographer. Nonetheless, in quick snapshots during a birthday party for instance, the framing will be superior to those obtained by merely pre-setting a single focal length.

Power focusing and power zooming is fun but increases battery drain. Besides, you can set more precise focus, or focal length, with the conventional lenses. Minolta has no plans to introduce additional xi zooms because of criticism of the type above. Nonetheless, if your family frequently uses your 700si, you may wish to buy an xi lens for their exclusive use.

Wide Angle AF Zoom Lenses

Minolta offers a true wide angle zoom with constant maximum aperture, the AF 24-50mm f/4.0. Granted, f/4 is not exactly

impressive, but keeps the price quite affordable. This is a zoom which will appeal to photographers who like to experiment with various wide angle focal lengths, varying the perspective.

An even longer range - from extreme wide angle to short tele-photo - is covered by the new AF 24-85mm f/3.5-4.5. This lens includes aspheric elements to improve its optical performance, increasing sharpness and contrast while reducing distortion.

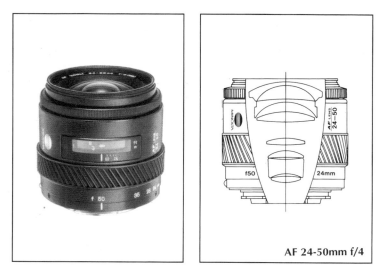

AF 24-50mm f/4

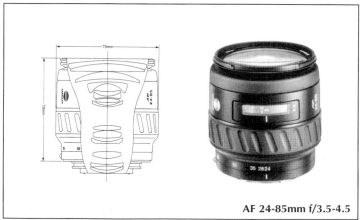

AF 24-85mm f/3.5-4.5

Anyone armed with this fine zoom will have a versatile combination from wide angle to normal, and portrait telephoto at his fingertips.

You'll find similarly versatile AF zoom lenses for the 700si, including several which start life at the popular 28mm focal

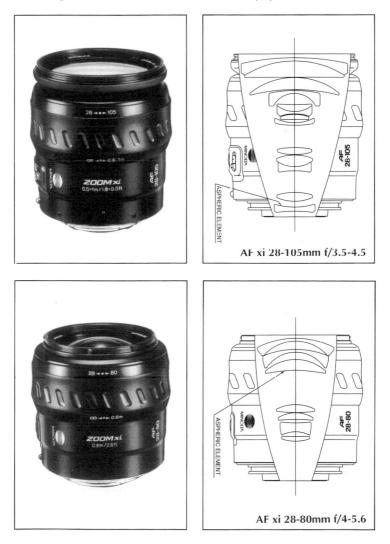

AF xi 28-105mm f/3.5-4.5

AF xi 28-80mm f/4-5.6

length and extend into the "normal" and short telephoto range. The photographer has a choice of three (non-xi) lenses: AF 28-80mm f/4-5.6, AF 28-85mm f/3.5-4.5 and the AF 28-70mm f/2.8 G. If you're looking for a particularly economical and light weight zoom, check out the new AF 28-80mm f/4-5.6, a "feather-weight" at 8.5 oz. (250g).

Our favorite, however, is the wide (constant) aperture AF 28-70mm f/2.8 G. It's larger, heavier and more expensive, but offers high quality optics (with aspheric elements) as evidenced by its "G" designation. For critical sharpness, it is a suitable alternative to fixed focal length lenses, matching the performance of many.

"Normal" AF Zoom Lenses

A full selection can be found in Minolta's AF zooms starting at 35mm (some are mentioned in the xi Zoom section). The AF 35-80mm f/4-5.6, AF 35-105mm f/3.5-4.5, are the available non-xi options. Some will be more attracted to the AF xi 35-20mm f/4.5-5.6 "Macro" zoom whose specs sound impressive. But a note of caution: we have not found the lenses with the widest range of focal lengths to be "best" among any group of zooms.

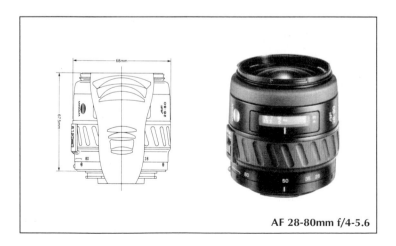

AF 28-80mm f/4-5.6

Variable Aperture Concerns

Most zoom lenses today feature variable maximum aperture, like f/4 to f/5.6. Aperture size is modest at the short end and diminishes as you zoom toward longer focal lengths. This strategy is

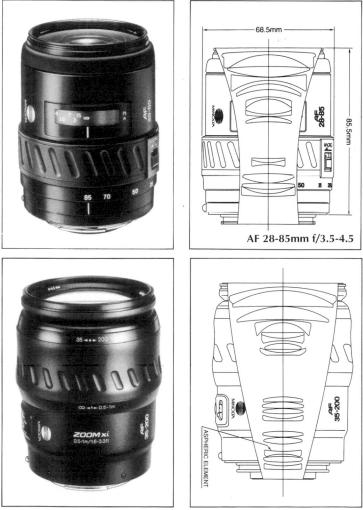

AF 28-85mm f/3.5-4.5

AF xi 35-200mm f/4.5-5.6 Macro Zoom

employed to keep lens size, weight and price to a minimum. With the Maxxum/Dynax system, (unlike some others), *the effective f/stop will vary only at the widest aperture setting.*

The TTL metering system compensates for this reduction, but you'll need to compensate yourself if using an accessory lightmeter or studio flash system at maximum lens aperture. Other f/stops remain constant; set the lens at f/8, for instance, and it will remain at f/8 throughout the focal length range.

Zoom Lens Evaluation

It's no secret that design requirements increase dramatically with the wider ranges. The AF 28-70mm f/2.8 G has a limited range for a specific reason: the complexity of the optical formula is minimized, allowing for maximum correction for aberrations. These are more difficult to correct when the designer is faced with the broad variety inherent in both wide angle and telephoto focal lengths. When a photographer invests a great deal of time in considering, arranging and selecting his subject, it would be a real shame to waste all this effort for a large print which is unsharp at the edges, for instance.

The difference in technical quality starts to become apparent once you get to 8x12 size prints and particularly noticeable in an 11x14 enlargement. If you are not satisfied with merely "good" pictures but require technical excellence, you'll want one of the "G" or "APO" designated zooms.

We are not suggesting for a moment that the inexpensive Minolta AF lenses are inferior. In fact, these offer good value for the money and respectable results at the mid-range of apertures. But even Minolta's computerized design equipment cannot work miracles. A lens with the enormous focal length range of 35-200mm (with "Macro" capability) which is still portable and affordable called for design concessions. While a perfect lens does not exist, a more modest zoom is easier to design and cheaper to make than one with a 6x range from wide angle to 200mm telephoto.

Some will consider this judgment a bit harsh or even exaggerated. Nonetheless, we feel it is especially justified with the 700si, since this not a beginner's camera but a superior SLR intended for

serious photography. The 700si can make creative pursuits a highly enjoyable experience. The right lenses are a critical part of the level of satisfaction with the end results of the image making process.

AF 35-80mm f/4-5.6 Power Zoom

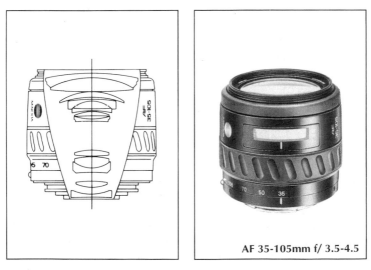

AF 35-105mm f/ 3.5-4.5

Telephoto Zooms

The last group of Minolta's AF lenses are the tele-zooms, which reach from the short to the extended zoom range. Firstly, there is a whole series of lenses in the 70mm to 210mm range. The success of zoom lenses started in this area and they remain popular

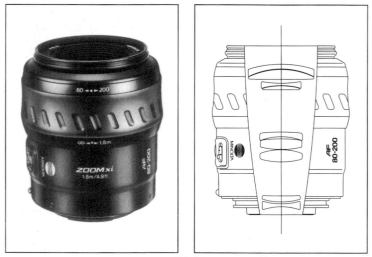

AF xi 80-200mm f/4.5-5.6 Macro Zoom

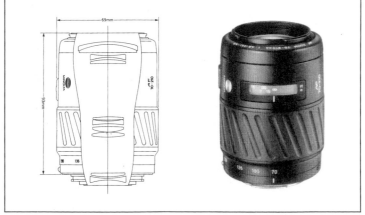

AF 70-210mm f/4.5-5.6

AF 70-210mm f/3.5-4.5

AF 80-200mm f/2.8 APO

173

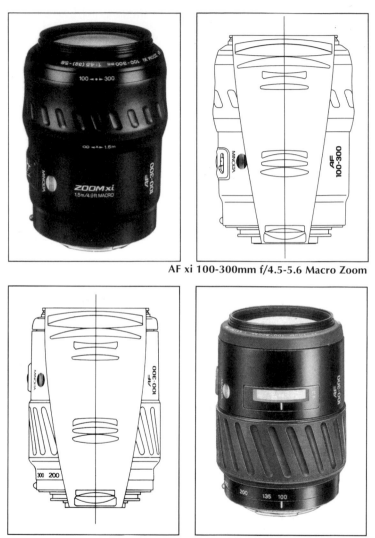

AF xi 100-300mm f/4.5-5.6 Macro Zoom

AF 100-300mm f/4.5-5.6

today. For example, such a lens combined with a 28-80mm zoom offers the entire range from wide angle to telephoto.

These two would cover the focal lengths needed for 75% of day-to-day photography. Consider 85-105mm as ideal for portrai-

AF 100-300mm f/4.5-5.6 APO

ture without an obvious telephoto look. Try 135mm for longer distances and more noticeable tele effects and finally 200mm with its compressed perspective, reduced depth of field, and limited separation of the subject from the background.

Even here the photographer has a decision to make: among the AF 80-200mm f/4.5-5.6, AF 70-210mm f/3.5-4.5 and our own favorite, the AF 80-200mm f/2.8 APO G. If you agree with the saying "One excellent lens over three or four good ones", you're a candidate for the AF 80-200 f/2.8 APO G as well. The apochromatic characteristics produce superior image quality, especially at wide apertures. The increased speed of roughly two stops (when compared to other zooms) should not be underestimated. This leads to more photographic freedom in faster shutter speeds, longer flash ranges, the ability to shoot handheld on overcast days and shallow depth of field to blur away a busy background.

Granted, the size, weight and price of this white beauty will take it out of the running when these penalties are significant considerations. Nonetheless, the demanding photographer would

Lens Specifications

AF Lens

Lens	Elements/ Groups	Angle of View	Minimum Focus	Minimum Aperture	Filter (dia.)	Dimensions (dia. × length)	Weight
AF 16/2.8 Fisheye	11/8	180°	0.7ft.	f/22	integral	2 15/16 × 2 5/8 in.	14 1/8 oz.
AF 20/2.8	10/9	94°	0.8ft.	f/22	72mm	3 1/16 × 2 1/8 in.	10 1/16 oz.
AF 24/2.8	8/8	84°	0.8ft.	f/22	55mm	2 9/16 × 1 3/4 in.	7 9/16 oz.
AF 28/2	9/9	75°	1 ft.	f/22	55mm	2 5/8 × 1 15/16 in.	10 1/16 oz.
AF 28/2.8	5/5	75°	1 ft.	f/22	49mm	2 9/16 × 1 11/16 in.	6 1/2 oz.
AF 35/1.4 G	10/8	63°	1 ft.	f/22	55mm	2 9/16 × 3 in.	16 9/16 oz.
AF 35/2	7/6	63°	1 ft.	f/22	55mm	2 5/8 × 1 15/16 in.	8 7/16 oz.
AF 50/1.4	7/6	47°	1.5ft.	f/22	49mm	2 9/16 × 1 1/2 in.	8 5/16 oz.
AF 50/1.7	6/5	47°	1.5ft.	f/22	49mm	2 5/8 × 1 9/16 in.	6 oz.
AF 85/1.4 G	7/6	28°30'	2.8ft.	f/22	72mm	3 1/16 × 2 13/16 in.	19 3/8 oz.
AF 100/2	7/6	24°	3.3ft.	f/32	55mm	2 5/8 × 3 in.	16 15/16 oz.
AF 135/2.8	7/5	18°	3.3ft.	f/32	55mm	2 9/16 × 3 1/4 in.	12 7/8 oz.
AF 200/2.8 Apo G	8/7	12°30'	4.9ft.	f/32	72mm	3 3/8 × 5 1/4 in.	27 7/8 oz.
AF 300/2.8 Apo G	11/9	8°10'	8.2ft.	f/32	integral	5 1/16 × 9 3/8 in.	87 1/2 oz.
AF 600/4 Apo G	10/9	4°10'	20ft.	f/32	integral	6 5/8 × 17 11/16 in.	194 oz.
AF Reflex 500/8	7/5	5°	13ft.	—	integral	3 1/8 × 4 5/8 in.	23 7/16 oz.
AF 24-50/4	7/7	84°–47°	1.1ft.	f/22	55mm	2 11/16 × 2 3/8 in.	10 1/16 oz.
AF 24-85/3.5-4.5 NEW*	14/12	84°–29°	1.6ft.	f/22-27	62mm	2 7/8 × 2 7/8 in.	14 1/8 oz.
AF 28-70/2.8 G NEW	16/11	75°–34°	2.3ft.	f22	72mm	3 1/4 × 4 9/16 in.	26 7/16 oz.
AF 28-80/4-5.6 NEW	7/7	75°–30°	2.6ft.	f/22-32	55mm	2 11/16 × 2 1/16 in.	8 7/16 oz.
AF 28-85/3.5-4.5	13/10	75°–29°	2.6ft.	f/22-27	55mm	2 11/16 × 3 3/8 in.	17 5/16 oz.
AF 35-80/4-5.6	8/8	63°–30°	1.6ft.	f/22-32	46mm	2 9/16 × 2 5/16 in.	6 7/8 oz.
AF 35-105/3.5-4.5	12/10	63°–23°	2.8ft.	f/22-27	55mm	2 11/16 × 2 5/16 in.	10 1/4 oz.
AF 70-210/3.5-4.5	12/12	34°–12°	3.6ft.	f/22-27	55mm	2 7/8 × 3 11/16 in.	14 13/16 oz.
AF 80-200/2.8 Apo	16/13	30°–12°30'	5.9ft.	f/32	72mm	3 7/16 × 6 9/16 in.	47 5/8 oz.
AF 80-200/4.5-5.6	9/9	30°–12°30'	4.9ft.	f/22-27	46mm	2 5/8 × 3 1/16 in.	10 1/4 oz.
AF 100-300/4.5-5.6 Apo NEW*	11/10	24°–8°10'	4.9ft.	f/32-38	55mm	2 7/8 × 4 in.	14 13/16 oz.
AF 100-300/4.5-5.6	11/9	24°–8°10'	4.9ft.	f/32-38	55mm	2 7/8 × 3 15/16 in.	14 7/16 oz.
AF 50/2.8 Macro	7/6	47°	0.7ft.	f/32	55mm	2 11/16 × 2 5/16 in.	10 5/16 oz.
AF 100/2.8 Macro	8/8	24°	1.1ft.	f/32	55mm	2 13/16 × 3 7/8 in.	18 5/16 oz.
AF Macro Zoom 3X-1X/1.7-2.8	7/5	8 × 12mm (3X)(1) 24 × 36mm (1X)(1)	Working Distance 1.0in. (3X) 1.6in. (1X)	f/16 (3X) f/27 (1X)	46mm	3 3/8 × 4 5/8 × 3 3/4 in.(2)	38 13/16 oz.
AF 1.4X Tele Converter II Apo(3)	5/4	—	—	—	—	2 1/2 × 13/16 in.	6 3/16 oz.
AF 2X Tele Converter II Apo(4)	6/5	—	—	—	—	2 9/16 × 1 11/16 in.	7 7/16 oz.

"G" designates G-Lens group, a selection of large-aperture, high-performance lenses.
Notice: When used with Maxxum 700xi, all AF lenses can be operated in either autofocus or manual focus mode Auto Zoom functions cannot be used.

(1) Size of subject that fills the film plane
(2) W × H × D
(3) For use with AF 200/2.8 Apo G, AF 300/2.8 Apo G, and AF 600/4 Apo G lenses only.
(4) For use with AF200/2.8 Apo G, AF300/2.8 Apo G lenses only. When using with AF 600/4 G autofocus and focusing signal cannot be used. Set the camera focus-mode switch to M and focus manually.
*Available early 1994.

Specifications and accessories are based on the latest information available at time of printing and are subject to change without notice.

Lens Specifications AF Zoom xi Lens

AF Zoom xi Lens

Lens	Elements/ Groups	Angle of View	Minimum Focus	Minimum Aperture	Filter (dia.)	Dimensions (dia. × length)	Weight
AF Zoom xi 28-80/4-5.6	7/7	75°–30°	2.6 ft.	f/22-32	55 mm	2 13/16 × 2 5/8 in.	9 11/16 oz.
AF Zoom xi 28-105/3.5-4.5	13/10	75°–23°	1.6 ft. (f = 28)	f/22-27	62 mm	2 7/8 × 3 in.	15 7/8 oz.
AF Zoom xi 35-200/4.5-5.6 Macro	17/15	63°–12°30′	1.6 ft. (f = 35)	f/22-27	62 mm	2 15/16 × 3 11/16 in.	17 5/8 oz.
AF Zoom xi 80-200/4.5-5.6 Macro	9/9	30°–12°30′	4.9 ft.	f/22-27	55 mm	2 7/8 × 3 3/16 in.	10 9/16 oz.
AF Zoom xi 100-300/ 4.5-5.6 Macro	11/9	24°–8°10′	4.9 ft.	f/32-38	55 mm	2 15/16 × 3 15/16 in.	15 1/2 oz.

AF Power Zoom Lens

Lens	Elements/ Groups	Angle of View	Minimum Focus	Minimum Aperture	Filter (dia.)	Dimensions (dia. × length)	Weight
AF Power Zoom 35-80/4-5.6 Macro*	8/8	63°–30°	1.6 ft.	f/22-32	49 mm	2 5/8 × 2 1/8 in.	6 3/16 oz.

*The Auto Zoom functions are not possible on AF Power Zoom 35-80mm Lens.

do well to own this APO tele zoom, one of the best of the entire Minolta AF zoom line. A lens of this type can effectively bridge the gap between pro and serious amateur, making it well worth considering for high caliber images.

And to complete the zoom lens circle, there is a choice of longer telephoto zooms. The (non xi) options are the AF 100-300mm f/4.5-5.6, the AF 75-300mm f/4.5-5.6, and the recently introduced AF 100-300mm f/4.5-5.6 APO. The latter, surprisingly petite, incorporates AD elements which correct the chromatic aberration characteristic of telephoto lenses. If you're planning to market your work or demand 11x16 enlargements of your favorite pictures, the enhanced performance will surely justify the additional cost of this APO zoom lens.

We see no merit in acquiring every focal length available but a new lens type can certainly enhance your abilities. Experiment until you learn how the new purchase, whether a 100-300mm telephoto zoom or an ultra wide, can best be used and begin to reshape your vision accordingly. Become proficient and the results can be extraordinary, perhaps matching the pictures we all admire in the finest magazines.

Accessories for the 400si and 700si

Although both si-series cameras come well equipped, Minolta offers various accessories which can help expand their versatility. In addition to lenses, flash units and flash accessories, the si system contains the following items. Some are compatible only with the 700si, this will be mentioned in the section for that item.

Vertical Control Grip VC-700

We consider the VC-700 Control Grip the single most useful accessory for the 700si (it is not compatible with the 400si) because it increases ease of use and offers a choice of three battery types. It was designed exclusively for these cameras and improves handling noticeably.

The grip has an additional trigger for use in vertical format plus a second set of the following controls: Spot and AF control buttons, front and rear control dials, grip sensor and tripod mount. Its controls can be turned off with a switch to prevent inadvertent activation when the camera is used in a horizontal format. The Grip can be used with the optional Holding Strap for even more secure handling.

The VC-700 takes over the power supply for the camera with a choice of 2CR5 lithium cell, alkaline AA batteries or rechargeable NiCds. The Grip incorporates a PC terminal which accepts sync cords from non-dedicated flash units and others without a hot shoe connector. When attaching a flash unit in this manner, set the shutter speed at 1/200 sec. or slower to ensure that it will sync with the camera.

The VC-700 may resemble an accessory motor drive but it does not increase the 3 fps film advance rate at all. While a lithium cell is the preferred power source, a 2CR5 is not always available when traveling; fortunately Alkaline AA's can be found virtually anywhere in the world, making these the ideal backup power source.

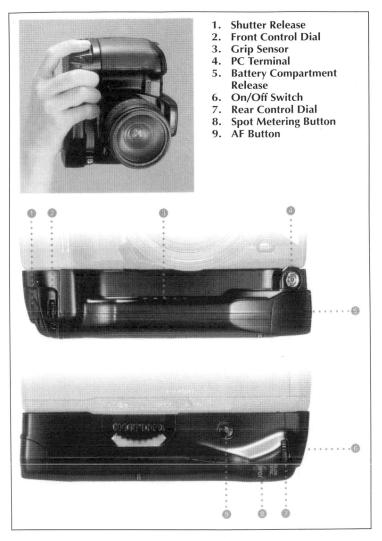

1. Shutter Release
2. Front Control Dial
3. Grip Sensor
4. PC Terminal
5. Battery Compartment Release
6. On/Off Switch
7. Rear Control Dial
8. Spot Metering Button
9. AF Button

Vertical Control Grip VC-700

Battery Performance with the VC-700

Flash Use	Lithium	AA alkaline	AA NiCd
0%	60	70	35
50%	25	25	10
100%	15	15	5

The above was based on Minolta's tests using 24 exposure rolls, at 68° F (20° C). In actual use, battery performance will be lower. At -4° F (-20° C) performance reduced by one third with Lithium, and over 50% with NiCds; alkalines provided minimal performance in such conditions.

Panorama Adapter Set

Control: To view the panorama frame in the viewfinder, press both the "AF" and "Card" buttons while turning the camera ON. Repeat the procedure to turn it off again.

Although it is possible to spend a small fortune on a true panoramic camera, Minolta's Panorama Adapter Set is an inexpensive alternative for those who want a narrow 13x36mm frame. This kit consists of a template which fits into the film gate where it's securely held by spring loaded pins to mask off a portion of the film frame. When inserted, only a 13x36mm section and exposed, corresponding to the section indicated on the viewing screen. The top and bottom third of the image will print as black, easily cropped off by your lab.

Insert this adapter and you can immediately take "panoramic" pictures with the 400si and 700si. In truth, this narrow image is more accurately called "stretch format" as compared to the longer band produced by true Panoramic cameras. These typically employ the entire width of two or more frames of film and offer a field of view of 110 degrees to an astounding 360 degrees (achieved with a rotating lens).

However, the definition of "panoramic" has expanded significantly over the past few years, used to denote any "elongated

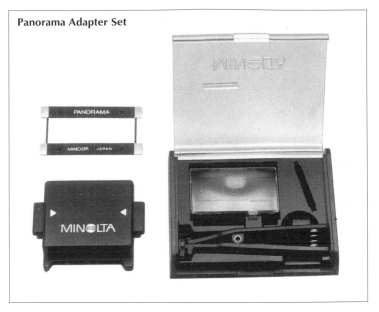

Panorama Adapter Set

aspect ratio". When taken with a wide angle lens (especially 24mm or wider) the 13x36mm frame does convincingly simulate a panoramic image. You can now include the sweeping vista of an expanse of mountains, an entire cityscape, or a bridal veil falls or skyscraper using the camera in a vertical orientation.

Now, a group of people, the cathedral, the arena or the skyline becomes the center of attention; extraneous details like the sky or the foreground are eliminated. This can lead to striking images, but only if used for appropriate subject matter. We recommend using the stretch format only for those which actually lend themselves to this approach; otherwise, the picture will be merely a novelty, without any powerful effect.

All camera functions such as autofocus, exposure metering, etc. continue to operate normally when the adapter is installed. Naturally, mid-roll switch to panoramic is not possible unless you rewind the film. To help decide whether a subject lends itself to the "stretch" composition, it is possible to preview the effect at any time using the Control procedure outlined above.

In truth, you do not actually need to buy an adapter. Your photo finisher can crop any print to the desired format, usually

for a small extra charge. Most labs do charge more for panoramic prints in any event. A 3-1/2" x 10" (9x25cm) enlargement is considered standard, but you may wish to ask for less expensive 3x5" or 4x6" proofs printed full frame.

Hint: When taking panorama shots with ultra wide angle lenses, use a negative film. Because the subject (or the area covered) will be large, the range of contrast will be high. Print films, thanks to their wider exposure range, will produce superior results than a slide film with its limited exposure latitude.

Panorama Head II

Compatible with any camera, the panorama head is mounted on a tripod and enables individual shots to be combined into a long, panoramic picture (generally glued onto a board in an abutting series). The lower section of the head has click-stops for positioning the camera for each frame, ensuring that the individual prints will all overlap slightly. The click-stops are marked for different focal lengths (28mm, 35mm, 50mm). Aligning the camera and head is best done with the help of a bubble level since matching photos later is practical only if they were all taken perfectly horizontal.

Panorama Head II

The panorama head is not a real alternative to true panoramic photography, however, since exact detail matching between foreground and background is not possible. Besides, it is not exactly simple to combine the images without leaving a visible seam between each. Nonetheless, some photographers have used this strategy to advantage, and Minolta's Panorama Head makes the shooting technique relatively simple and accurate.

Lens Hoods

You'll notice that Minolta includes a lens hood (or shade) with most of its AF lenses and offers an optional hood for the others. We consider this device essential for serious photography as a hood shields the lens from side light. This reduces the amount of stray light striking the front element, thus minimizing the risk of flare which would reduce image contrast, wash out colors and reduce the overall impression of sharpness.

Flare is of particular concern when shooting with zoom lenses. Their numerous glass to air surfaces make them particularly vulnerable. Unfortunately, the hood is designed for the widest focal length in the zoom's range - for 28mm in an AF 28-80mm zoom, for example. This is essential to prevent vignetting (darkening at the edges of the frame) at the longer focal lengths but makes the hood virtually useless by 50mm in the example above. Hama, Hoya and some other accessory manufacturers offer an adjustable or "universal" hood. These are useful from about 28mm to 105mm if adjusted according to the focal length in use.

Hint: Avoid the other "generic" hoods sold to fit any lens. These are usually designed for a 50mm lens and will vignette with wider focal lengths. With a telephoto, their effectiveness is minimal. When using the built-in flash of the 700si, remove the hood with certain lenses (listed in the Owners' Manual); those of wide diameter will interfere with the light resulting in uneven illumination, especially with closeups.

Carrying Cases

Minolta offers a carrying case that is just large enough to hold the camera and a lens. It is appropriate for the photographer who only owns one lens, or is traveling light on an arduous hike. The equipment is protected (but not as well as in a padded bag) and the camera can be accessed fairly quickly for shooting. Often called an "everready" case, some consider this type a "never ready" case. Carrying the 400si or 700si (without a case), with lens mounted (and in the case of the 700si, with the Eye-Start activated) allows you to shoot instantly when an opportunity presents itself.

Domke F3X Super Compact Bag

Camera Bags

If, on the other hand, you really set out for some serious photography, you'll want a camera bag such as one of the *Domke®* models or a vest such as the *DOMKE Photogs™ Vest* with its numerous pockets. Both products were designed by a professional photographer and we have found them highly useful in the field

Needless to say, you'll find numerous other brands advertised, including the hard shell (waterproof) cases which resemble a suitcase. This type is ideal if you're boating or traveling in the tropics or desert as it's well sealed against water, humidity and fine dust. We find these less than convenient when walking, however, since they rarely include a shoulder strap. A "fanny pack" like the *Orion II AW* from Lowepro® is a far more convenient alternative for hiking, backpacking or cross country skiing.

There is wide range of styles and formats on the market, from rustic to elegant. You may well find you'll need two: one for short trips with all of your equipment, and the other for more arduous journeys when you'll take only the essentials. The first must be adequately large to hold the camera and all its accessories. Buy one which is larger than you currently need, so it will hold a new flash unit or telephoto lens acquired later.

Make sure that the zippers are covered by overlapping flaps so that water cannot enter from the top. A completely water-proof bag cannot be made, but it should at least be adequate to keep the equipment dry in a rain shower. Only then can you confidently take the camera along when the sky holds threatening clouds. The bottom of the bag should be reinforced so it can be carried with a heavy load without bending.

The equipment dividers should be padded to protect valuable equipment from banging. Domke patented dividers have sewn in

bottoms to eliminate "wandering" equipment and to make changes from one bag to another quick and easy.. A variable interior with Velcro® fasteners is the most versatile so that the inserts can be arranged in a format which is specifically set up for your own equipment and style of photography.

Focusing Screens for the 700si

Changing the focusing screen may be desirable in certain situations. Minolta offers two optional screens for the 700si (only). The first is etched with cross-hairs (as in a rifle scope) and a scale; it's useful for macro and micro photography where the reproduction scale is critical. The other is etched with a full grid pattern, useful for composing with the Rule of Thirds, for example.

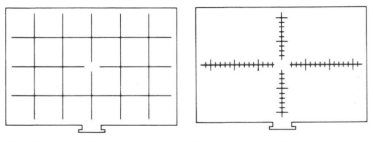

Focusing screen, Typ I Focusing screen, Typ S

The 700si's focusing screen can be exchanged for a more appropriate version by a Minolta Service Center.

The latter is also recommended for reproduction work where it is imperative that the subject is exactly parallel or plumb. Hence it is the best choice for architecture and product photography - furniture or a building, for example. The screens can only be changed by a Minolta Service center, however, so you'll want to be certain as to which is likely to be most suitable for long term use. We find the grid pattern screen particularly valuable for much of our work.

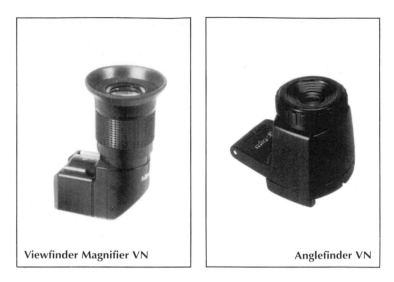

| Viewfinder Magnifier VN | Anglefinder VN |

Eyepiece Correctors

Minolta offers nine different correction lenses for their si-series cameras for mounting on the viewfinder's eyepiece. Near- and far-sighted photographers can thus add diopter correction in (+ and -in steps of 0.5) and shoot without wearing their glasses. This allows the eye to be held closer to the eyepiece, for an improved overview of the composition and data displays.

The camera body comes with a -1 diopter built-in, suitable for most people with good eyesight. This should be kept in mind when selecting an accessory corrector. The best place to pick the right diopter is in the store where it is possible to try several. The correction lenses are intended for near- and far-sighted photographers and will not correct for other conditions such as astigmatism.

If the appropriate lens is not made by Minolta, the correction frame is the answer. An optician can grind the a lens to fit this frame to perfectly suit your own eyes.

Viewfinder Magnifier VN

The viewfinder magnifier can be mounted on the eyepiece (-instead of the eye cup) if you want to enlarge the image in the

central area of the viewfinder 2.3 times. It is designed for macro photography but not for normal work since the entire frame is not visible. One can focus more precisely when using this magnifier, assuring critical focus on exactly the right subject plane.

Those with less than 20/20 eyesight will like the fact that the diopter level can be steplessly selected. Once focus has been achieved, the Magnifier can be flipped up so the entire field of view can again be seen.

Anglefinder VN

The right-angle finder VN allows for comfortable viewing when using a tripod, even in awkward positions (as when the camera is mounted, inverted, on the center post). The image can be seen from the top or from the side, presented upright and the right way around. It has a built-in diopter control and can be swung 360 degrees to the desired position. The Anglefinder VN is also recommended for photo micrography, copy stand work, or with very low camera positions.

Remote Cord RC-1000L and RC-1000S

As mentioned in a previous Chapter, a remote trigger is useful to guarantee shake-free photos when the 700si is mounted on a tripod. While the self timer can achieve this, too, a ten second delay is not always ideal. Besides, when shooting on "bulb" a locking trigger is the most convenient (and vibration free) technique for long, timed exposures.

Remote Control Cable RC

Since the conventional mechanical cable release devices cannot be used with most autofocus/multi-mode SLR cameras, you'll need to buy one of these RC cords for remote triggering of the 700si. If you frequently use a tripod, consider this accessory as an essential part of your Maxxum/Dynax system. (Since the 400si will not accept a Remote Cord, use the self timer, instead, for vibration-free shutter release.)

The hand-grip button of both RC models can be locked by pressing and sliding it forward, making long exposures (in "bulb" setting) easier and more comfortable. Otherwise, the shutter only remains open as long as the release button on the camera is depressed in "bulb" mode. Without a locking remote trigger, this can be inconvenient and tedious in exposures over 30 seconds. Camera shake is also a possibility.

The RC-1000L ("Long") can be used up to 12' (5m) away from the camera (as in portrait work, for instance) while the RC-1000S ("Short") is useful when you're standing near the camera. The trigger can be programmed for a 2 second delay or you can trip the shutter at any time.

Wireless Controller IR-1N Set

For triggering the 700si from long distances (as in wildlife photography for instance) the IR-1N infrared remote control set is required. Similar in concept to a television remote controller, the IR-1N consists of transmitter and a receiver for controlling the 700si (with or without flash) over long distances. The actual range depends on the terrain but will be adequate for most any application. (This Set is not compatible with the 400si.)

The unit has three channels, making it possible to control three cameras (or groups of cameras) individually by remote control. If several photographers are in the area, switching channels also helps to avoid triggering each other's equipment. Unlike radio remote control systems, the user does not need to be in view of the camera being controlled. However, triggering is most certain when the two units are within sight of each other and few obstacles exist in the area.

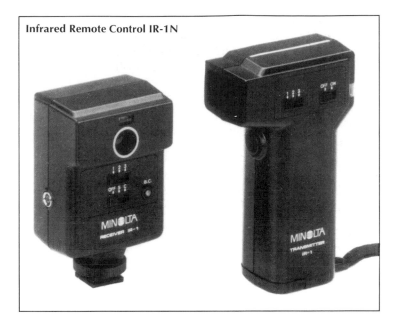

Infrared Remote Control IR-1N

Achromatic Close-up Lenses

When even a "Macro" zoom lens cannot focus close enough for the magnification required, supplementary close-up lenses can be useful. Similar to filters with + diopter glass, Minolta's achromatic close-up lenses consist of two coated elements for superior optical quality. Achromatic lenses are corrected for aberration, so they will produce superior image quality to the inexpensive single element models. They are also preferable to extension tubes and bellows in close-up work with lenses not specifically designed for close-focusing. Nonetheless, stop down by two or three stops (from the widest aperture) to achieve optimal image quality.

Interesting facts become apparent if a few combinations are calculated out. The effect of a close-up filter increases with increased focal length. If a +5 diopter close-up lens is used on a 50mm lens, a maximum reproduction ratio of 1:2.5 is possible. A 250mm telephoto lens with the same supplementary lens can

Minolta Portrayer Filters

produce a reproduction ratio of 1:3.1, and all this without the light loss which would be caused with extension. We like the AF 100-300mm APO zoom for nature close-up work, as it allows for varying the focal length to isolate small elements (such as a stamen) when desired.

Minolta offers four lenses in two strengths and two mounts, each available in 49mm and 55mm threads. Use an adapter ring for smaller filter thread diameters. Those designated as 1 and 2 are intended for 50mm lenses while the I and II series are designed specifically for telephoto focal lengths from 85mm to 200mm. While these will not replace the true macro lens for serious work, the price makes them highly desirable for occasional close-up photography, especially with nature subjects where flatness of field is not an essential consideration.

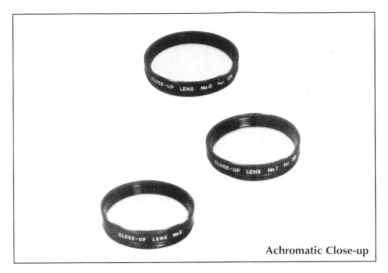

Achromatic Close-up

Tripods

Photographers have always had a love/hate relationship with the tripod, an essential accessory for sharp pictures but inconvenient to carry and adjust. Nonetheless, every photo enthusiast should own one since the use of flash is often inappropriate or impractical.

The tripod's primary function is to hold the camera rock steady to prevent the adverse effects of vibration. While high quality lenses and films hold the potential for ultra-sharp pictures, disappointment is likely unless the equipment is supported by a stable platform.

A tripod offers the luxury and ease of careful study of composition on the focusing screen. You can effectively make small adjustments until the image is exactly as desired. It also makes a variety of special effects possible: panoramic sequence shots, zooming during a long exposure, smoothly panning with an action subject, or depicting the fluid motion of a waterfall or wildlife subject. Just as important is the flexibility to select whatever f/stop will most effectively depict your subject. To achieve extensive depth of field in macro or landscape work, for example, f/16 or f/22 will call for long exposures. These mandate the use of three steady legs.

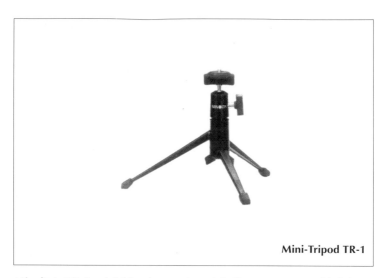

Mini-Tripod TR-1

Minolta's TR-1 mini-tripod cannot match the support provided by a more substantial model but it is highly compact and lightweight.

Lugging a heavy tripod can be intolerable, but a lightweight model with spindly legs can be worse than no support at all. It will sway in the lightest breeze when extended. If you routinely work with the 700si and a zoom lens up to the weight of the AF 80-200mm f/2.8 APO, consider a tripod in the three to four pound (1.5 to 2 kg.) range. Combined with a solid head, this will support your equipment with stability while remaining portable.

The best of these (such as the Benbo®) offer structural integrity adequate on all but the most windy days. A more substantial model is likely to be left behind when you venture any distance from the car. That's why a compromise is generally in order: a medium weight model may not damp all vibrations in all conditions, but is more likely to receive regular use. Look for one with legs of tubular aluminum, and avoid using full extension when possible. If the ability to work in water is important, consider the Benbo models. This brand is also highly versatile thanks to its bent bolt axis construction; this makes setting the camera in any position possible in uneven terrain.

For action photography with long telephotos we recommend a monopod to support the equipment. Properly used, it allows two additional shutter speed steps. In other words, the AF 300mm f/2.8 APO can be used without a tripod at 1/125 sec. instead of the usual 1/500 sec. needed for sharp pictures hand-held.

Now the camera remains highly mobile, but is also supported adequately to ensure sharp pictures even if the shake warning appears in the viewfinder. A monopod cannot, of course, replace a tripod for all situations, but the "fast" f/1.4 to f/2.8 AF lenses make it more practical than one of the "slow" zooms. Compared to the AF 100-300mm f/4.5-5.6 at 300mm, the AF 300mm f/2.8 offers a maximum aperture two stops greater, reducing the need for a tripod as long as you can shoot wide open. Let's say that a certain situation requires a shutter speed of 1/60 sec. with the zoom (at f/5.6); the prime lens can be used at a higher speed of 1/250 sec. This means the difference between needing a tripod or getting by with the convenience of a monopod.

Other Accessories

The Minolta catalog lists other items compatible with the 400si and 700si, including flash connector cords, various caps, filters, copy stands, and holders, a sturdy mini tripod, and some highly regarded accessory light meters. Naturally, aftermarket suppliers offer some similar products and most everything else you could ever need.

But a word of warning: these cameras are built with the latest technology; some products said to be compatible with "Maxxum/Dynax cameras" may not interface properly with the fourth generation **si**-Series. Many flash units fall into this category, for example. When in doubt, deal only with retailers who guarantee a refund in the event of less than full compatibility. Read the owner's manual which comes with your new purchase to be certain. You should at least find an insert detailing use with the si-series, which was probably released after the accessory device was manufactured.

Although Minolta brand products occasionally cost more, full compatibility will be guaranteed as long as the dealer's accessory catalog includes reference to either the 400si or the 700si.

Insuring Your Equipment

Though not an accessory per se, an insurance policy which provides full coverage for your valuable Maxxum/Dynax equipment offers peace of mind. If you are an amateur photographer your Homeowner's (or Tenant's) Policy should already offer some protection; check the wording for specifics as to off-premises coverage especially. For a nominal price, you can add a camera equipment floater increasing the perils which are covered and probably the amount of protection for off-premises losses. Should you drop the 700si, for instance, a floater will probably provide coverage while the standard policy would not.

Check with your insurance agent or broker for specifics as policies can vary from company to company. But do ask about replacement cost coverage. Should your equipment be lost or destroyed, you could claim the current replacement cost instead of contending with heavy depreciation. If an "All Risk" Floater is available, most common causes of loss will be covered. This may include mysterious disappearance and destruction or damage unless caused by war, nuclear energy, wear and tear, rust, scratching or marring, defects and so on. Read the list of exclusions closely, as no policy covers "everything" no matter how broad it may seem.

If you are a professional photographer, the above will not suffice. You'll need to buy a commercial insurance policy for the equipment to cover your liability, etc. Associations often offer coverage to members at reduced rates, so check on this possibility before getting quotes from agents or brokers on your own.

Again, seek coverage on a replacement cost basis. Otherwise, the insured value of your equipment will be its current market value - with deduction for depreciation, which can be heavy for commercially-used equipment.

Notes

Notes